SOUTH JERSEY
THROUGH TIME
Keith E. Morgan

AMBERLEY PUBLISHING

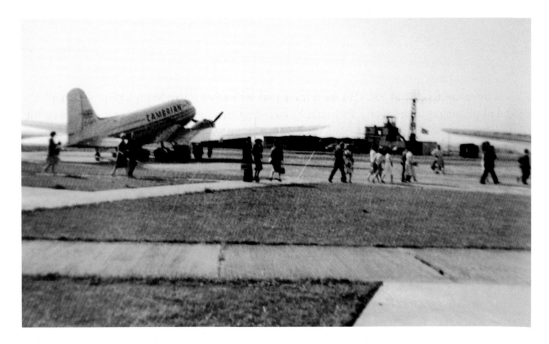

Preparing to take off from Cardiff Rhoose Airport – Destination Jersey, the Honeymoon Island!
In the 1950s and 1960s, Jersey was famously known as the Honeymoon Island. Hundreds of British couples flocked to the resort every year with their holiday in Jersey starting at the mainland point of departure, whether by sea or air. The picture, taken on Saturday 18 June 1960, shows a Cambrian Airways Douglas Dakota DC-3 on the tarmac at Rhoose Airport, Cardiff, waiting to take author Keith E. Morgan and his wife Malvina to spend a romantic honeymoon in Jersey. In those days, the ex-RAF Control Tower was still in use for Air Traffic Control and passengers walked across the runway to board their flight.

This book is dedicated to Malvina, 'My Special Angell',
in memory of all the happy times we spent together on the Island of Jersey.

First published 2012

Amberley Publishing
The Hill, Stroud
Gloucestershire, GL5 4EP

www.amberley-books.com

ISBN 978 1 4456 0621 7

British Library Cataloguing in Publication Data.
A catalogue record for this book is available from the British Library.

Typeset in 9.5pt on 12pt Celeste.
Typesetting by Amberley Publishing.
Printed in the UK.

Introduction

This is the second book in what is now a three-part series that traces Jersey's history through the media of photography. So many photographs were acquired for the project that it was impossible to do justice to such a wonderful island as Jersey with just one publication to include them all.

Starting at Jersey Airport and following the routes of the two old railways, this book covers the south coast of Jersey from St Ouen's Bay and La Corbière in the west to Gorey and Mont Orgueil Castle in the east.

Our point of arrival on the island is Jersey Airport, and our journey itself begins with a journey; that from our point of departure. Following the end of the Second World War and the German Occupation of the island, Jersey became famously known as the 'Honeymoon Island'. British Tax Laws at this time encouraged couples to get married before the beginning of the tax year in April whereupon they obtained a year's tax benefit. Hundreds of couples took advantage of this tax loop hole and flocked to the island early in the year. This did not mean that the remainder of the year was quiet on the island. Far from it; Jersey had developed into an attractive holiday resort and tax free haven, encouraging other honeymoon couples and holiday makers to travel to the island from sea ports and airports throughout the British Isle as well as from neighbouring France. The island heaved with hotels, nightclubs and duty free shops selling wines, spirits, beer, cigarettes and cosmetics. A far cry from today, where life on the island is very much in line with that experienced on the mainland. Nevertheless, Jersey still encourages those visitors who are looking for good accommodation, good food and a semi-tropical climate to enjoy the wonderful scenery and sandy beaches, as well as a warm and friendly welcome from the island's inhabitants.

If the traveller flies in from the west, the view of Jersey is extraordinary. Before touch down at Jersey Airport, opened as late as 1937, the aircraft flies in over St Ouen's Bay, known also as the Five Mile Beach with its golden sand stretching from Etacquerel in the north, to the rocky outcrop of La Corbière, with its famous iconic lighthouse, in the south. From La Corbière, our journey in the book follows the route of the Jersey Railway. Opened on 25 October, 1870, as a standard gauge (4 foot 8 ½ inches) line, the route of the Jersey Railway ran from St Helier to St Aubin. It was converted to narrow gauge (3 foot 6 inches) in 1883 and extended to La Corbière with the first through service from St Helier taking place on 5 August 1885. The Jersey Railway was finally closed in early 1937 following increased competition from buses and private cars, and a disastrous fire in October 1936, which destroyed the roof of the St Aubin terminal station. Many of the station buildings along the route of the old line still exist and have been converted for other uses. At our starting point, the old station at La Corbière is now a private house whilst others serve as cafés and public buildings as we shall see.

From La Corbière, we travel to St Aubin, taking a diversion *en route* to visit the Bays at St Brelade's and Portelet before continuing our journey east along the wonderful coastline of St Aubin's Bay via La Haule and Beaumont. After Beaumont, we take another short diversion up St Peter's Valley to the German Underground Hospital before returning to rejoin our route again at Bel Royal. We then continue on to Millbrook, First Tower and West Park to finally arrive at our destination, the old Jersey Railway terminal building at The Weighbridge, St Helier. It is worth noting that during the Occupation, the Germans re-opened almost the entire route previously followed by the St Helier to La Corbière line, as a narrow gauge (3 foot 3 ⅜ inches) mineral railway.

On our arrival at St Helier, we have to change railway companies and follow the route of the old Jersey Eastern Railway to Gorey in the east of the island. This railway was opened as a standard gauge (4 foot 8 ½ inches) track in 1873 and ran from the Snow Hill terminus in St Helier to the harbour at Gorey with its iconic Mont Orgueil Castle overlooking the harbour railway terminus there. Unlike the railway station buildings on the Jersey Railway, which were more or less all of individual designs and construction, those on the Jersey Eastern Railway followed a standard and unique pattern. Each was substantially built of stone with their architecture closely resembling that of wayside railway stations in Normandy. They all characteristically had a two storey Station Master's house with a single storey ticket office and waiting room butted on and in line alongside. This design has been attributed to the influence of the Jersey Eastern Railway Engineer, Hammond Spencer, who was a pupil of Monsieur Buddicom of Rouen. As the traveller journeys from St Helier to Gorey Pier, diverting to take in Elizabeth Castle and Havre des Pas *en route*, many of the old Jersey Eastern Railway station buildings can still be identified like those at St Luke's, Samarès, La Rocque (in 1781 the French landed here and marched to St Helier where they were defeated at the famous Battle of Jersey), Fauvic, Grouville and Gorey Village, albeit now as private residences. The Jersey Eastern Railway finally closed down in 1929, and like its counterpart in the west, was almost completely re-opened by the Germans during the Occupation as a narrow gauge mineral line and of which, nothing now remains.

The third and final part of the trilogy is covered in *North Jersey Through Time*. This will starts its journey at Gorey and takes the reader first north and then west to traverse the picturesque valleys and follow the rugged coastline until it reaches St Quen's Bay and finally Jersey Airport at St Peter's. *En route*, the book photographically captures and illustrates scenes of particular interest such as La Hougue Bie, Lily Langtry's Birthplace, Durrel's Conservation Trust (The Zoo), the Pallot Steam Museum and many, many more examples of Jersey's wonderful treasures.

Keith E. Morgan

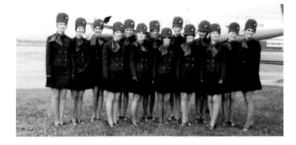

Cambrian Airways Air Hostesses, 1972
Third from right, air hostess Carol Butler of Porthcawl, South Wales, is now Carol George, Sales & Marketing Director of the Porthcawl based travel firm Traveland (Wales) Ltd. These were the glamour days of the airlines when to become an Air Hostess was almost equivalent to reaching stardom.

Cambrian Airways was set up as Cambrian Air Services in April 1935 and, except for a short break during the Second World War, remained operational until 1976. It was the first British airline to restart operations in 1946 following the end of hostilities. Based at Cardiff Wales Airport, it operated routes between Cardiff, Bristol, Birmingham, Southampton, Jersey, Dinard and Paris as well as charter flights to Rimini, Palma, Nice, Valencia and Barcelona. Starting with a single de Havilland DH60 Moth aircraft, it progressed through de Havilland Dragon Rapides, Auster Autocrats, Percival Protors, de Havilland DH 104 Doves, de Havilland DH 114 Herons, Douglas Dakota DC-3s, Vickers Viscount 701s and finally BAC 1-11 jets.

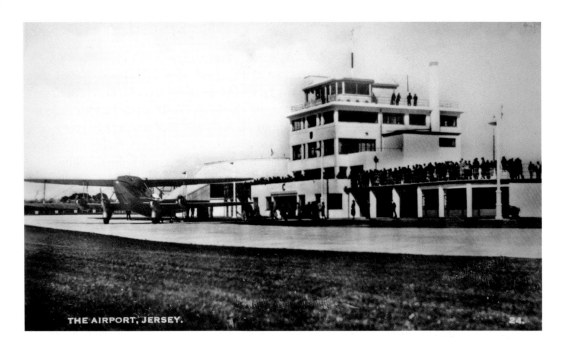

THE AIRPORT, JERSEY.

24.

Jersey Airport

Judging by the number of spectators on the first floor 'promenade' of the Terminal Building, this photograph was possibly taken when the airport was officially opened by Lady Coutanche on 10 March 1937. The four-engine biplane on the tarmac in front of the original 'Wedding Cake' structure Terminal Building, is a Jersey Airways de Haviland DH86 Express; probably one of the aircraft that made an inaugural flight to the new Jersey Airport. Compare its size with the Aer Lingus aircraft shown in the 2011 picture.

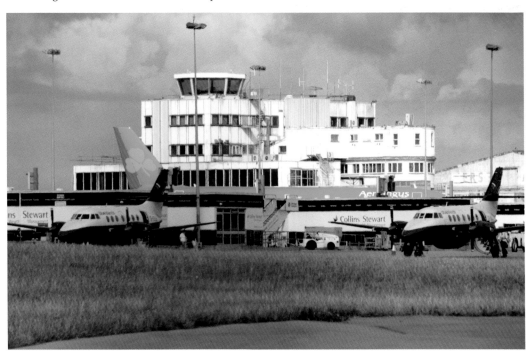

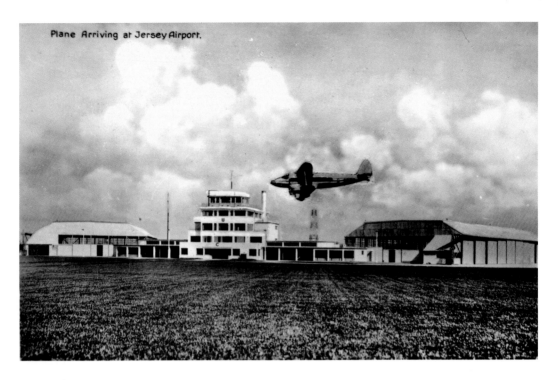

Jersey Airport

A DH86 Express biplane preparing to land in front of the impressive terminal building between 1937 and the end of 1939 when services were suspended due to the Second World War. In contrast, the yellow Aurigny Trislander coming in to land in front of the terminal building in 2011, highlights the development that has taken place at Jersey Airport since the end of the German Occupation.

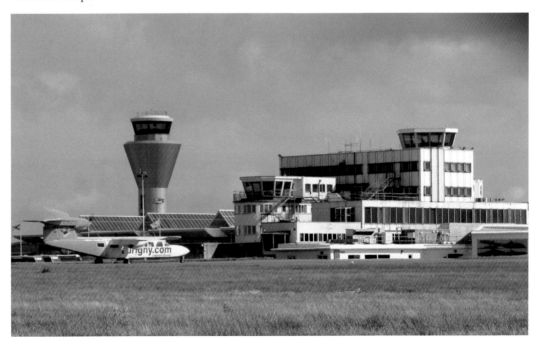

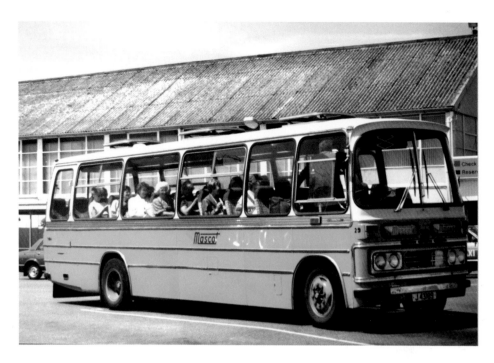

Airport Transport

As with aircraft using Jersey Airport, the road transport service to and from St Helier has changed. The 'Mascot' coaches of the 1980s have now been largely replaced by the 'Connex' streamline ultra-modern double-decker buses. Following trials in April 2010, these were introduced on Airport Route 15 in June 2011, and were the first double-deckers in regular service on the island since the 1970s.

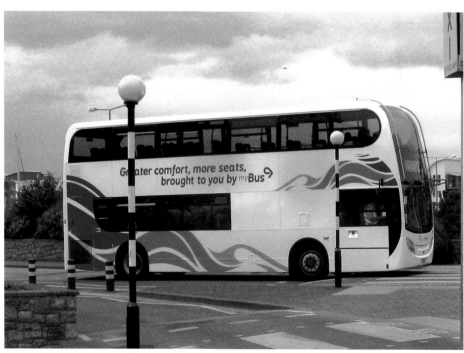

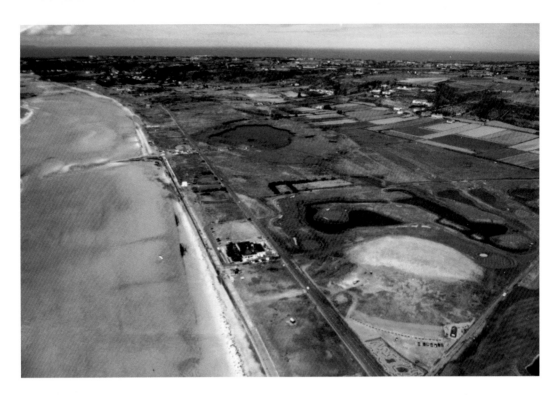

St Ouen's Bay, Five Mile Beach
The air traveller's view of Jersey when landing at the airport from the west. The top photograph shows the beach stretching north to Etacquerel while to the south, the golden sands extend past La Rocco Martello Tower to the rock outcrop of La Corbière with its famous iconic lighthouse.

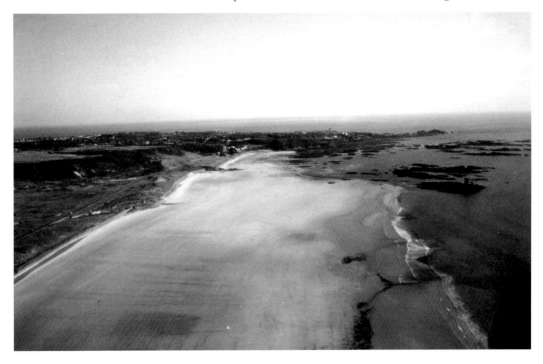

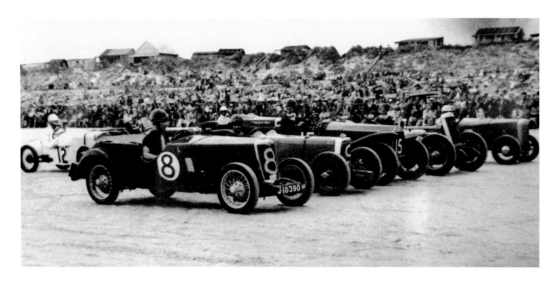

Motor Racing on the Five Mile Beach

Purpose built racers lining up on the beach at St Ouen's for the start of the 1937 '50 Mile Grand Prix'. In contrast, the 'racing cars' on the same stretch of beach in 2011, are 'tuned-up' standard production-built motor cars. Sand racing at St Ouen's in the 1950s was an entirely different matter as shown in the inset photograph where Milly and Kay Munkley from Bridgend, South Wales are admiring a real sports car – the Jaguar XK120!

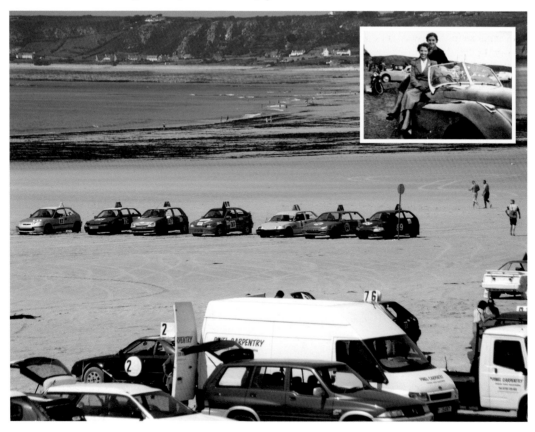

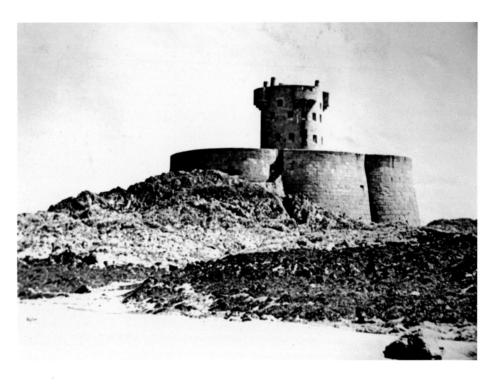

La Rocco Tower, St Ouen's Bay

One of Jersey's iconic structures, La Rocco Tower, St Ouen's Bay (constructed *c.* 1795), shown in the 1930s and today. In reality, a small fort because of its bulwark base, it is also the last of the pre-Martello round towers. Damaged accidentally in late 1944 by a young German gunnery trainee, it was restored to its original state in the 1970s.

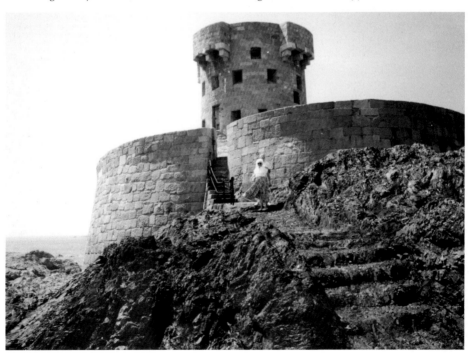

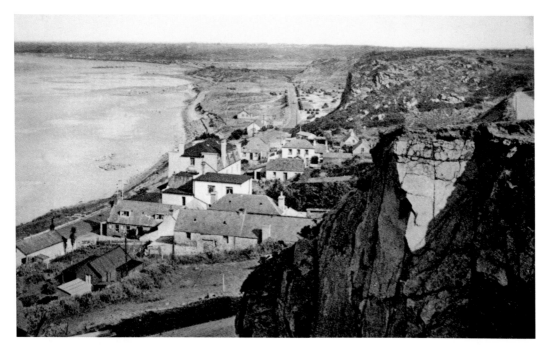

La Pulente, St Ouen's Bay

Situated at the southern end of St Ouen's Bay, except for minimal housing development, very little has changed in the small and confined hamlet of La Pulente. This is illustrated in the two photographs which were taken from virtually the same vantage point overlooking the hamlet in the 1930s and 2010.

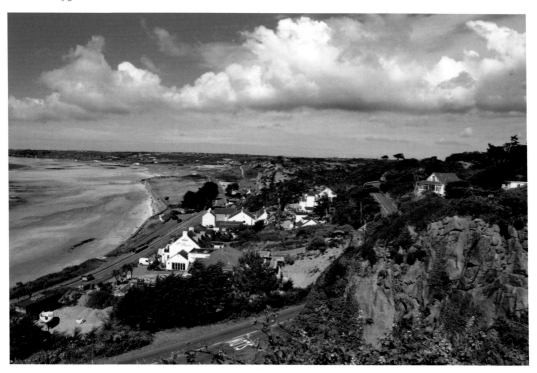

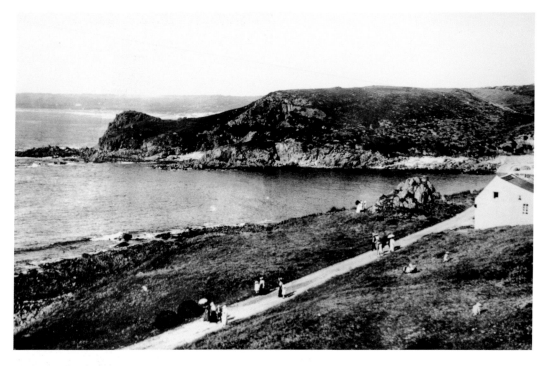

La Grouet, Petit Port

Not quite identical photographs, but they serve to show the development that has taken place since the 1930s and 2010 on the hillside at La Grouet overlooking Petit Port and La Corbière lighthouse.

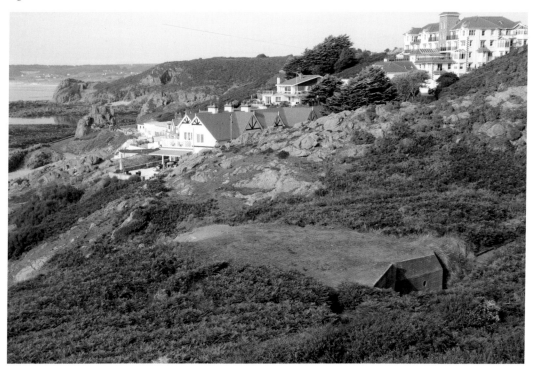

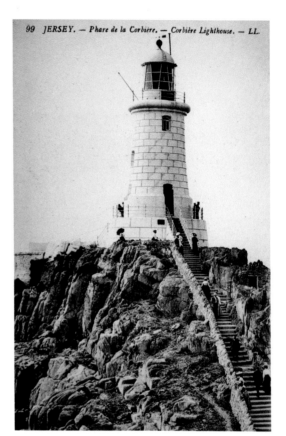

La Corbière Lighthouse

Perhaps the most famous, and possibly the most photographed of Jersey's iconic structures, La Corbière lighthouse. Designed by Sir John Coode, the lighthouse was completed in November 1873 and brought into service in April the following year. It was the world's first concrete lighthouse and cost just over £8,000. It is situated on the south-west corner of the island where this part of the coast had a fearsome reputation amongst sailors and was the scene of many ship wrecks; the latest being the French ferry *Saint Malo* on 17 April 1995.

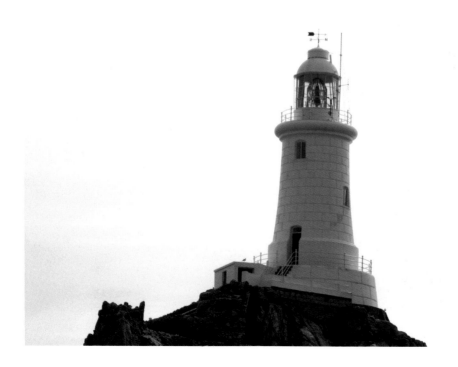

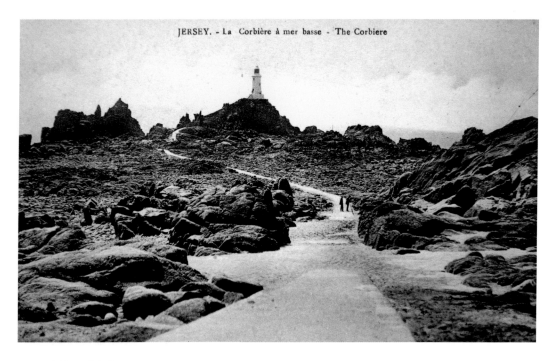

La Corbière Lighthouse

The lighthouse, which is 35 ft high, is built on solid rock, 500 yards from the shore and is accessible on foot via a causeway at low tide. It was automated in 1976 and is unmanned. Except for the additional concreting of the causeway, very little has changed between the 1930s and 2010.

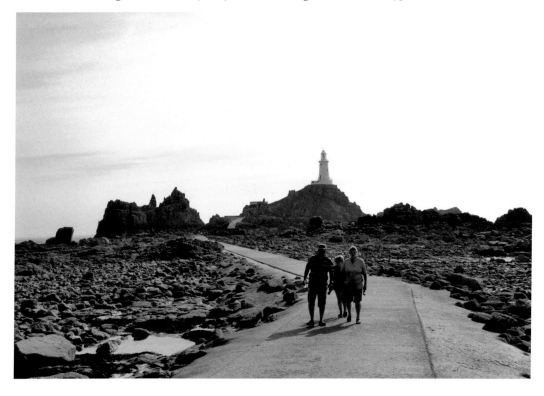

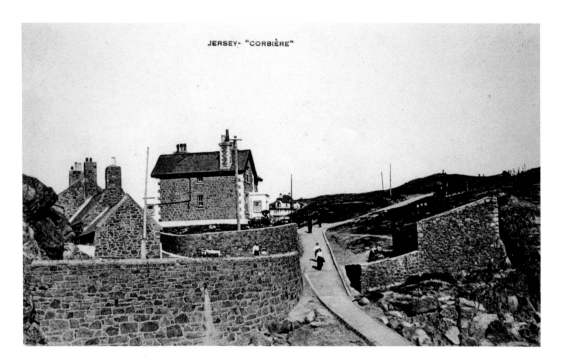

La Corbière Lighthouse

Comparative views from the causeway looking towards the shore from the direction of La Corbière lighthouse. Again very little has changed during the intervening years between the 1930s and 2010. The tides in this area are treacherous, exemplified by the carved stone tablet mounted on the wall alongside the causeway. It records and commemorates Peter Edwin Larbalestier, the assistant lighthouse keeper, who drowned trying to rescue a visitor cut off by the tide on 28 May 1946. The tablet carries this warning: 'TAKE HEED ALL YE WHO PASS BY'.

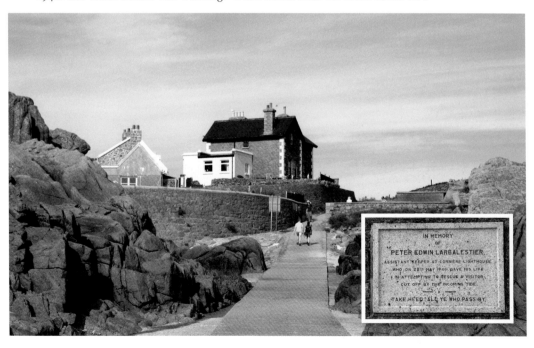

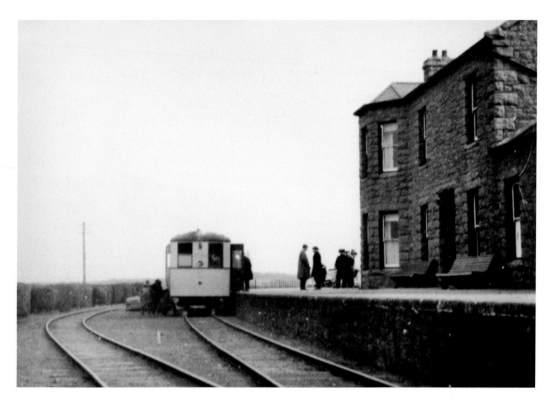

La Corbière Railway Station

La Corbière was formerly the western terminal of the Jersey Railway line from St Helier with the first through train running from St Helier to this terminus on 5 August, 1885. Unable to compete with motor cars and buses, and coinciding with a disastrous fire that destroyed the roof of the railway station and rolling stock at St Aubin, the line closed in 1937. The picture, taken before line closure in 1937, shows what looks very much like a steam railcar standing at the station. These railcars were first introduced in 1923 to help cut the costs of operations.

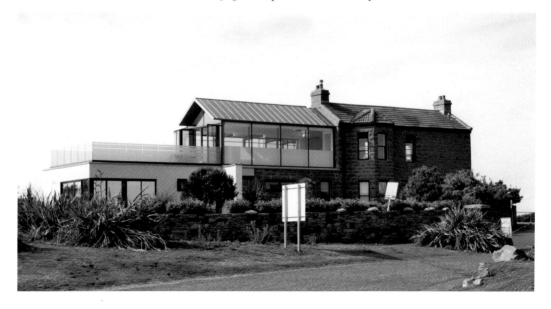

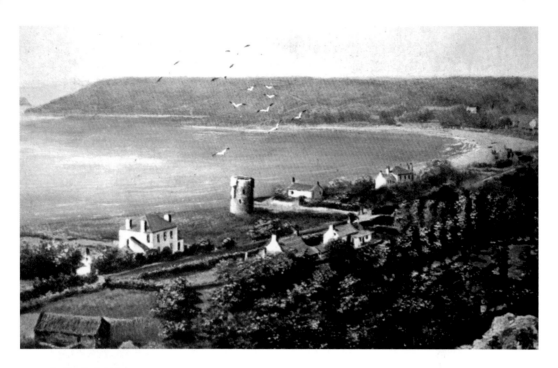

St Brelade's Bay

At this point, the reader is taken on a short diversion from the route of the old Jersey Railway to visit St Brelade's Bay and Portelet Bay. The overall view of St Brelade's Bay shown in the two photographs, serves to illustrate the changes that have taken place since the early 1900s. Many hotels have been built along the coastline, and the hillside from where the photographs were taken is now covered by urban development.

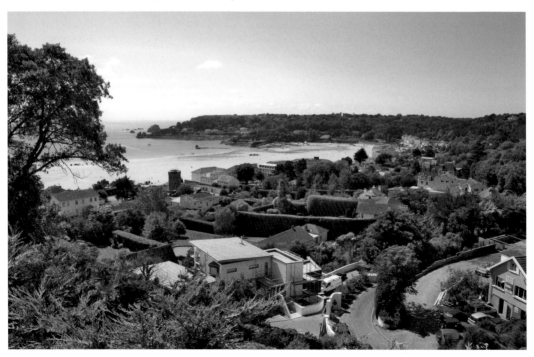

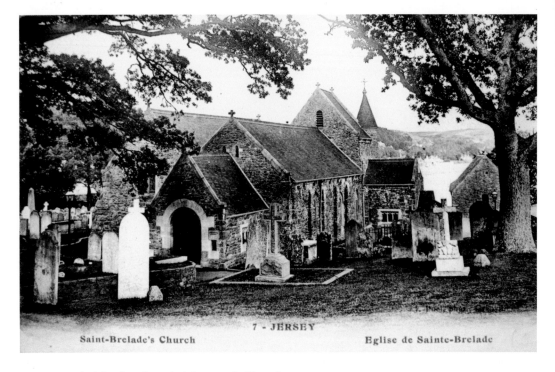

7 - JERSEY
Saint-Brelade's Church Eglise de Sainte-Brelade

St Brelade's Church and Fisherman's Chapel

A Celtic church probably existed on this site as early as the eighth century. However, the church dedicated to a Celtic monk, St Brelade, embodies the earliest Norman architectural remains on the island. Alongside the church and standing perilously on the cliff edge, is the eleventh/twelfth-century granite built Fisherman's Chapel, which has some fine early wall paintings. During the Occupation, a German cemetery was located in the churchyard, but was cleared in 1961 when the remains were removed to the German War Graves Commission Charnel House at *Mont de Huisnes*, Normandy.

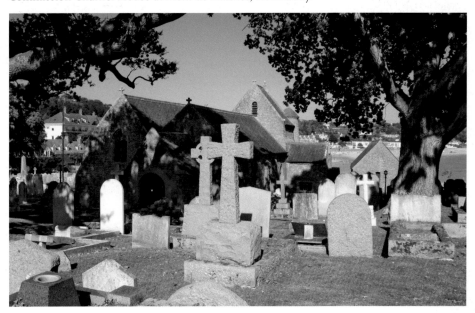

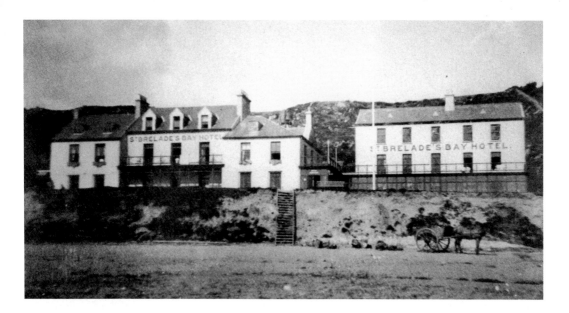

St Brelade's Bay Hotel

The St Brelade's Bay Hotel, which has been in the same family for five generations, started life in the late nineteenth century as a public house. At that time, apart from the parish church, there were only four farms, some fishermen's cottages and the Martello Tower in the bay. The St Brelade's Bay Hotel was the very first to open in the bay with others following apace in the late 1950s. Originally two buildings, these were joined together after 1924 and form the basis of the present hotel. The modern picture taken in 2011 also highlights the sea wall, a relic of the German Occupation.

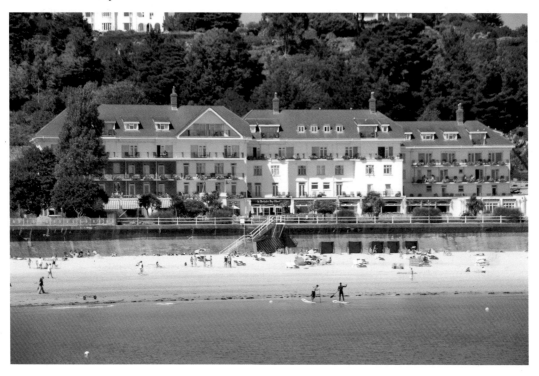

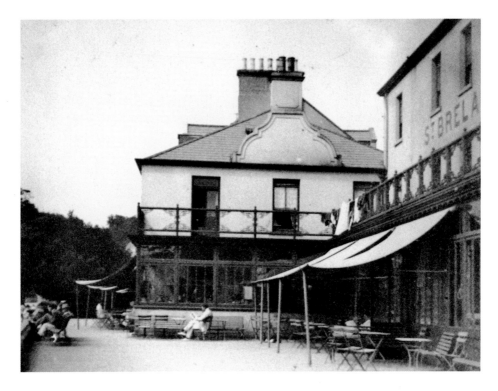

St Brelade's Bay Hotel

Two more views of the St Brelade's Bay Hotel. The old photograph was taken before 1924 and the other in 2011. During the Occupation, the hotel was taken over and used as a *Soldatenheim* by the Germans, a place of rest and recreation away from the front line. After 1945, the hotel was completely refurbished and extended to be ready to take advantage of the holiday boom which started in the late 1950s. Today, the St Brelade's Bay Hotel is one of the most prestigious on the island.

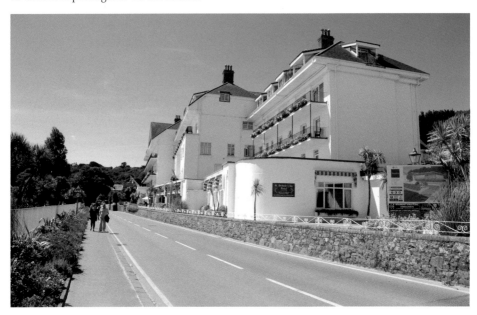

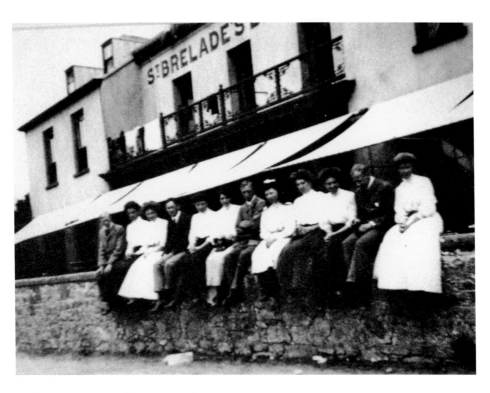

Staff at the St Brelade's Bay Hotel

What a difference these three photographs serve to show when comparing the number of staff employed at the St Brelade's Bay Hotel in the early 1900s, in 2004 (inset) and in 2011. The latter photograph was taken by Matt Porteous and illustrates how many disciplines are involved in running an efficient modern high standard establishment like St Brelade's Bay Hotel.

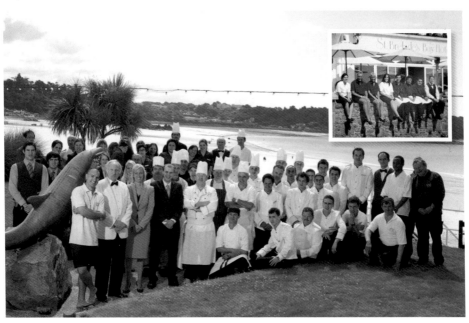

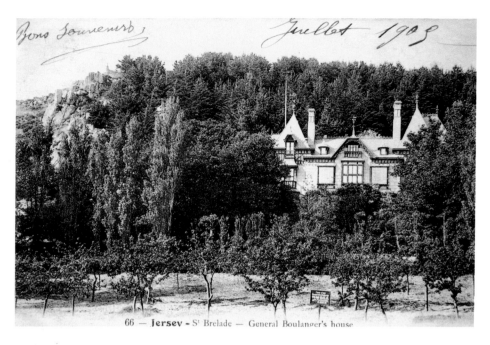

66 — **Jersey** - S^t Brelade — General Boulanger's house

General Boulanger's House, St Brelade's Bay

General Georges Boulanger, a controversial French politician, fled France on 1 April 1889 fearing arrest by the French Government. He arrived in Jersey in October 1889 to reside in St Brelade's Bay. His stay, however, was short lived. On the death of his beloved mistress in July 1891, he returned to Brussels and committed suicide at her graveside on 30 September 1891. The old picture of his house was taken after his death as there is a 'For Sale' notice posted out in front. The property is now being extensively developed as shown in the 2011 photograph.

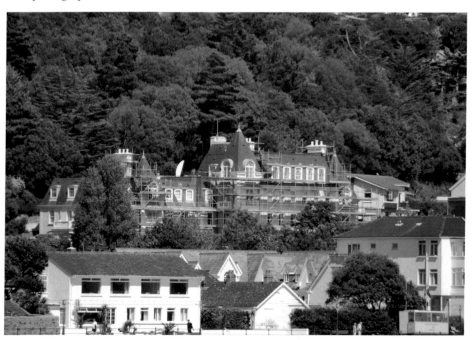

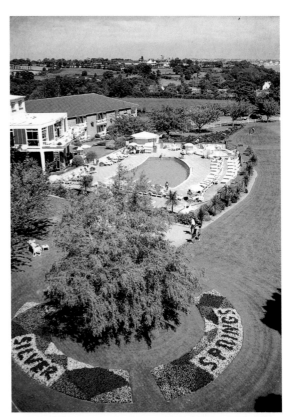

Silver Springs Hotel at St Brelade's
Silver Springs Care Home was once a former luxury hotel of the same name and was sold out to Four Seasons Health Care Ltd in 2004. What was once the Silver Springs Hotel, has been sympathetically converted and extended to become a residential care home for the elderly.

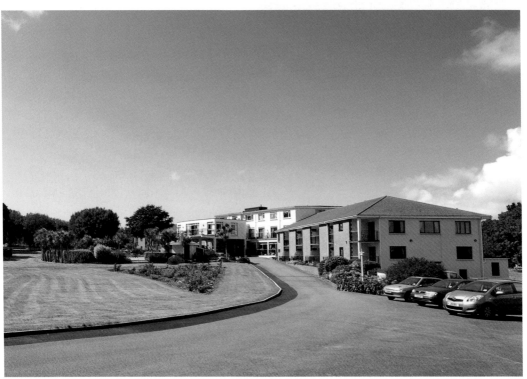

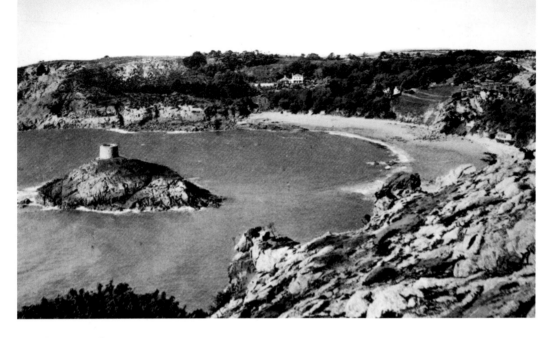

Portelet Bay and Tower

Portelet Tower, styled on the Martello design, was built in 1808 during the Governorship of General Don, on the islet in the bay known as Ile au Guerdain. It is popularly known as Janvrin's Tomb because sea captain Philippe Janvrin who died of plague, was buried here long before the tower was built. Considerable building development has taken place along the ridge of the bay as can be seen from the modern photograph.

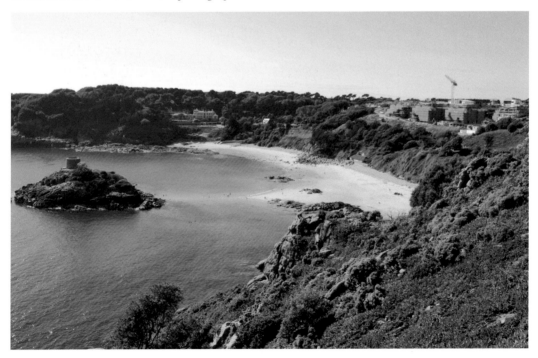

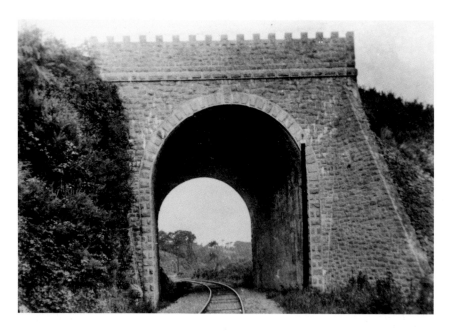

The Railway Walk

At this point, we return to the route of the old Jersey Railway. The States of Jersey purchased the former railway track on 1 April 1937 and created a trail known as the Railway Walk linking La Corbière and St Aubin for use by pedestrians and cyclists. The bridge under La Grande Route de St Brelade (A13), was built in 1885 and the old photograph taken before 1937 when the track was still in place before the line closed.

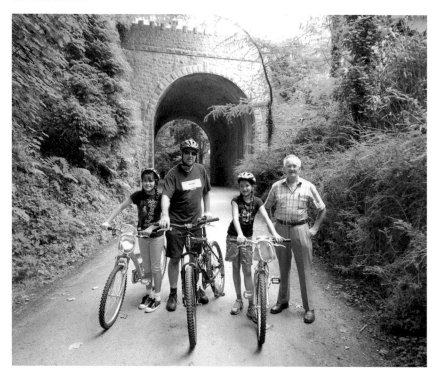

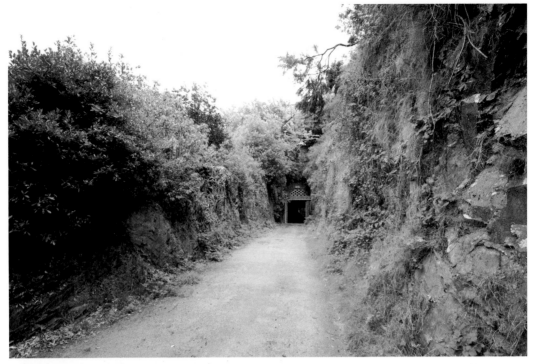

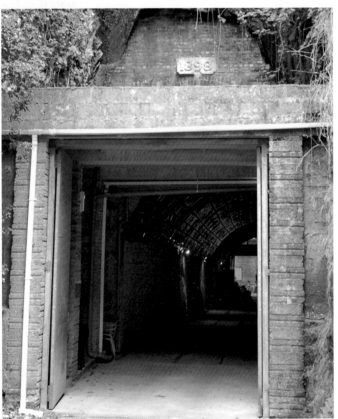

The St Aubin Railway Tunnel

The photographs show the Corbière side of the St Aubin railway tunnel. The tunnel was built in 1898 to avoid trains having to negotiate the tight reverse curves of the original track which traversed around the rock face just a few hundred yards outside St Aubin station. The gradient at this point was also a severe 1 in 40 from St Aubin *en route* to the next station at Greenville, resulting in the latter being closed on 30 June 1899 due to difficulties in stopping and starting on this gradient.

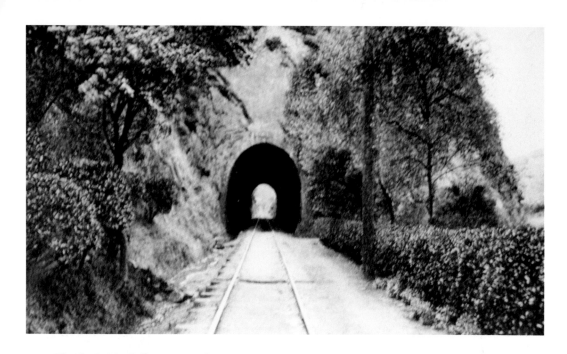

The St Aubin Railway Tunnel

The 'sea' side portal of the tunnel (dated 1898) seen as constructed and at the present time where the entrance is obscured from view due to the German 'pill box' style wall built in front of it. The Germans used the tunnel as a munitions store during the Occupation.

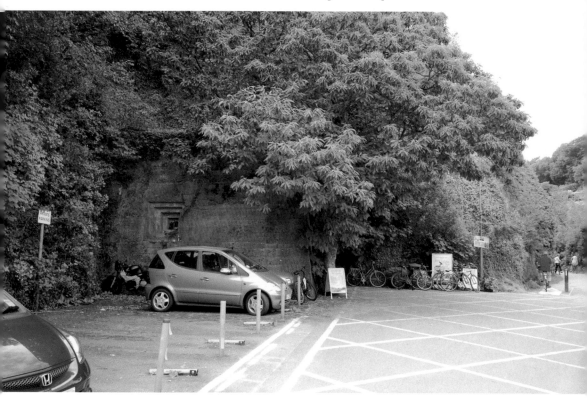

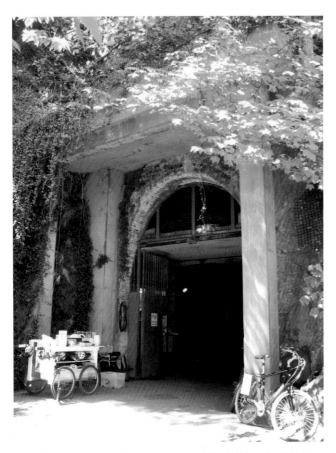

The St Aubin Railway Tunnel
The 'sea' side portal of the tunnel as seen behind the German 'pill box' style wall. This part of the tunnel is now utilised by a Cycle Hire company whilst the main section of the tunnel is used to garage Le Petit Train whilst it is not in service with access being obtained at La Corbière entrance. Note the embedded rail track still *in situ* inside the tunnel.

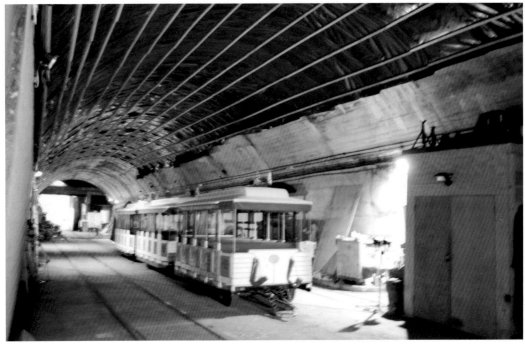

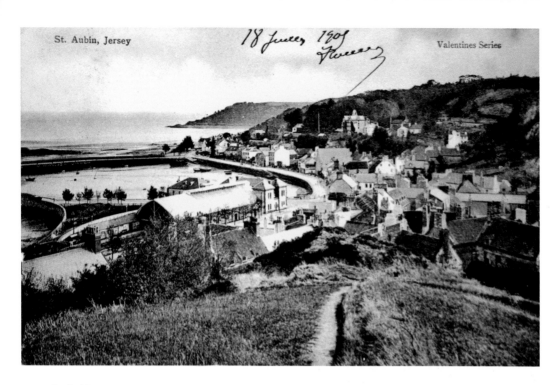

St. Aubin, Jersey *18 Juillet 1905* Valentines Series

St Aubin

Two comparative views of St Aubin. The first from a postcard dated 18 July 1905; the second taken from almost the same photographic vantage point overlooking the town in 2010.

The curved roof of the St Aubin terminal building of the Jersey Railway is clearly visible in the 1905 view along with the hotel that butted onto the station, and the spur line to La Corbière that curved sharply around the front of the station and hotel before crossing the road and disappearing into the hill and tunnel on the other side.

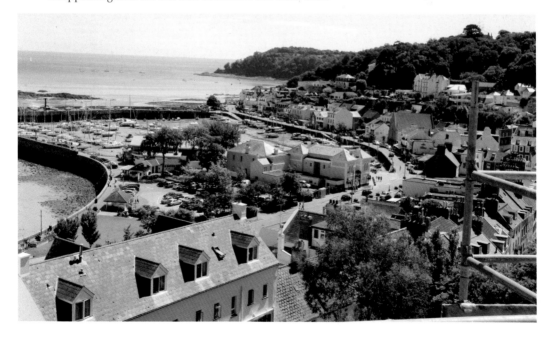

29

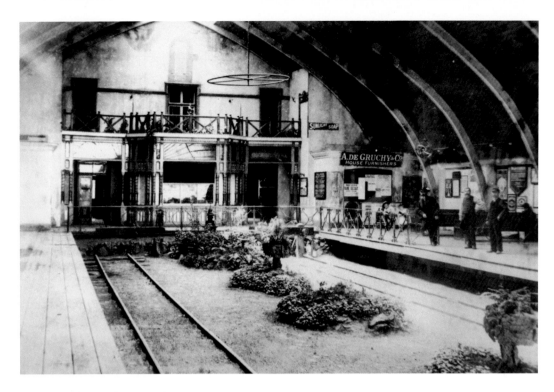

St Aubin Railway Station

The terminus building of the Jersey Railway at St Aubin, pre 1936, before the disastrous fire that gutted it. A fire destroyed the roof of the building in October 1936 at the same time consuming sixteen carriages. This, together with strong competition from motor transport, led to the closure of the line in early 1937. The site of the old station is now a car park with the back of the original hotel clearly visible.

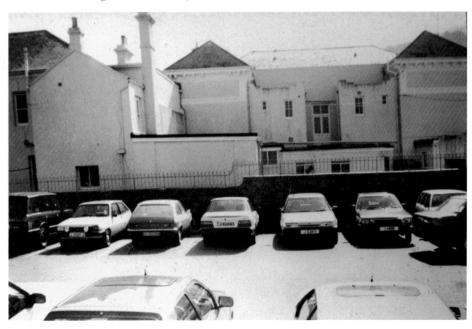

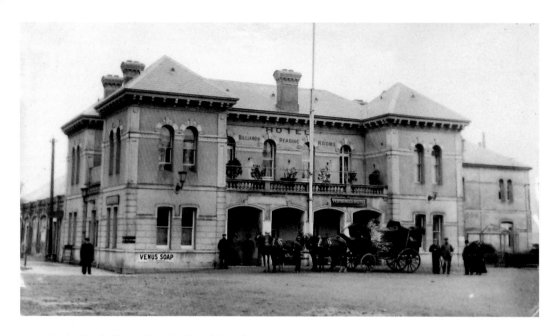

St Aubin Railway Terminal and Hotel

The 'Terminus Hotel' at St Aubin with what looks like a party waiting to be taken on a coach excursion. The photograph was probably taken in the 1880s. The building no longer houses a hotel, but instead the Offices of the Parish of St Brelade. It has changed very little physically other than to acquire a clock on its front as shown in the 2011 photograph.

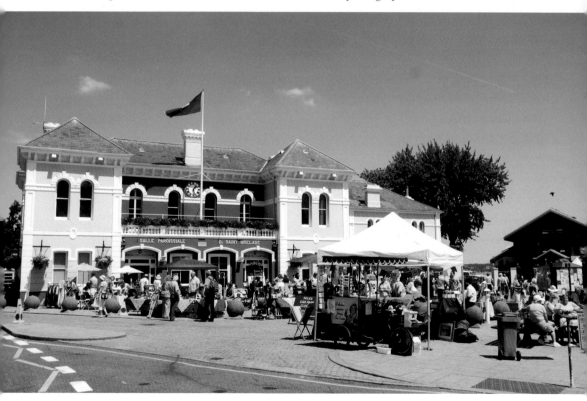

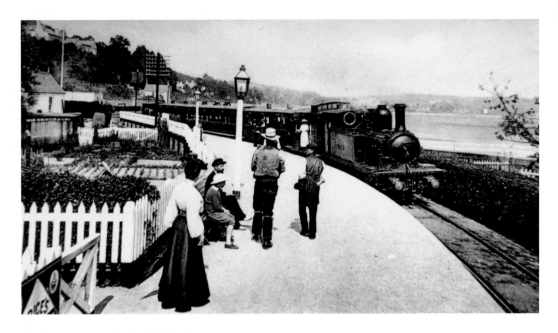

Platform No. 3 at St Aubin Station

This new platform was built for the through trains from St Helier to La Corbière with the first train making the journey on 5 August 1885. The picture was taken before September 1906 with locomotive No. 3 'Corbiere' waiting to take a train round the sharp curve in front of the 'Terminus Hotel' and on to the end of the line. By comparison, Le Petit Train is captured in the 2011 photograph travelling on the same route, but in the opposite direction to St Helier.

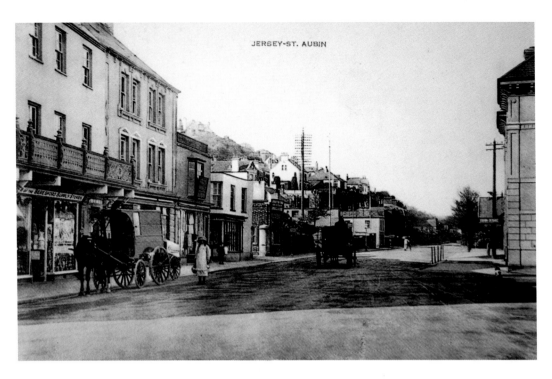

St Aubin

The two views of the main shopping centre of St Aubin show how little has changed (except for the traffic) between the late 1800s/early 1900s and the present day.

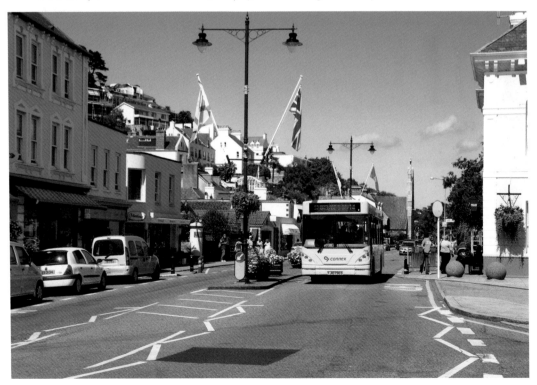

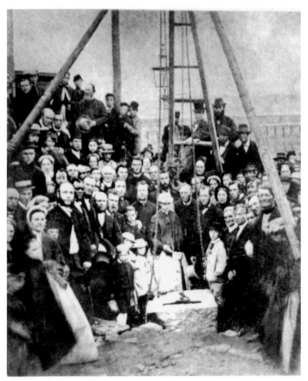

St Aubin Methodist Church

The first Methodist Church, seating 230, was built in 1817 on the site of what is now the church hall whilst the Foundation Stone for the present St Aubin Methodist Church was laid on 8 August 1867. In the 1930s, the central rostrum was removed to reveal the apse while renovations in 1995 gave 'open access' of the church to the passer-by. Further improvements were made in 2006 when a new organ was installed. The inset taken in 2011, shows the Jersey Harmony Men performing in the church.

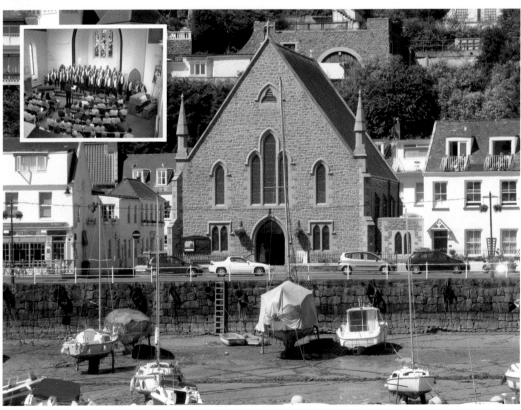

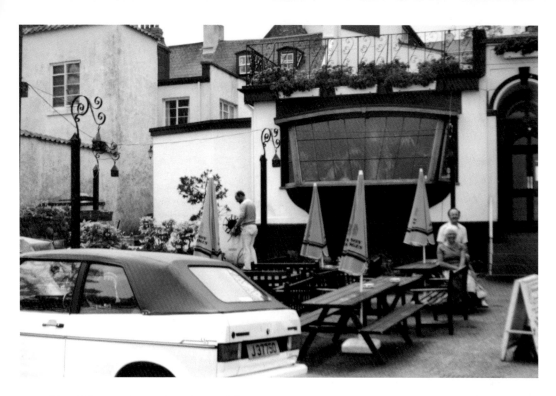

The Old Court House Hotel, St Aubin

The haunt of Jim Bergerac in the TV series *Bergerac* (1981–1991). With its characteristic galleon style stern window, 'The Royal Barge' as it was called in the TV series, is where Jim (played by John Nettles) would meet with his friends and colleagues under the watchful eye of 'Diamanté Lil', the landlady. Still a very popular venue for locals and holiday makers alike, the hotel and restaurant has long reverted back to its original name of the 'Old Court House'.

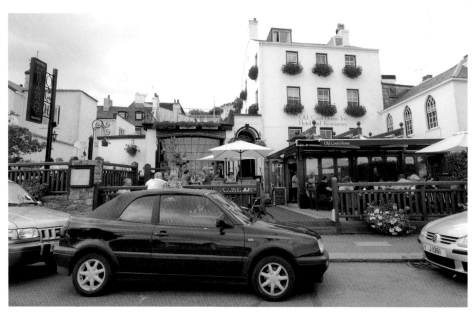

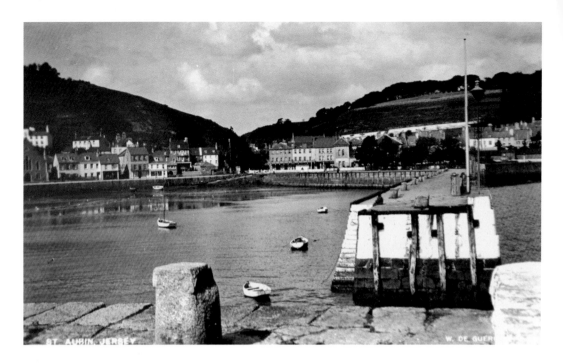

The Harbour at St Aubin

Contrasting views of the harbour at St Aubin taken in the 1930s and 2010. Both pictures have been taken from the same vantage point except that the position of the present day photographer was higher due to the German bunker that had been built on the end of the pier during the Occupation. What was once a quiet little fishing village has now developed into a bustling marina and holiday resort.

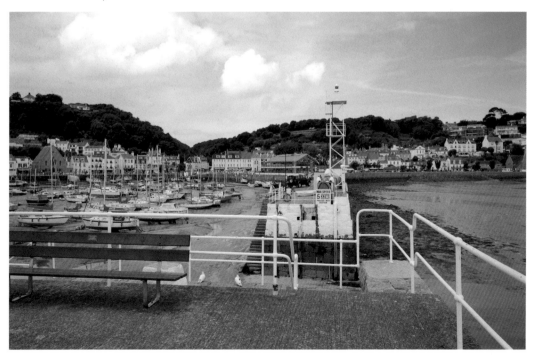

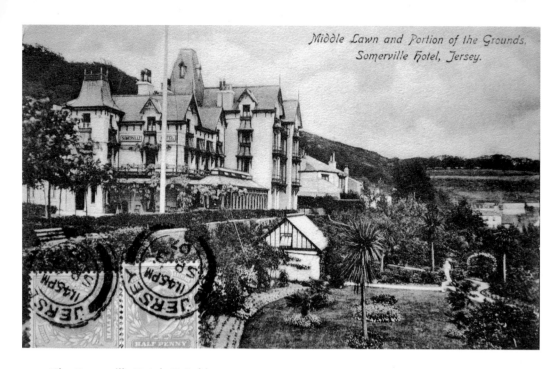

Middle Lawn and Portion of the Grounds, Somerville Hotel, Jersey.

The Somerville Hotel, St Aubin

The Somerville Hotel was probably built in the 1880s or 1890s as it appears to be very well established in the old picture postcard, which is franked 3 September 1907. Major development and expansion has taken place since that time as can be seen in the photograph taken of the hotel and grounds in 2011. With its commanding position overlooking St Aubin, this 'Country House' style luxury hotel presents enchanting views of the village, harbour, fort and bay of the same name.

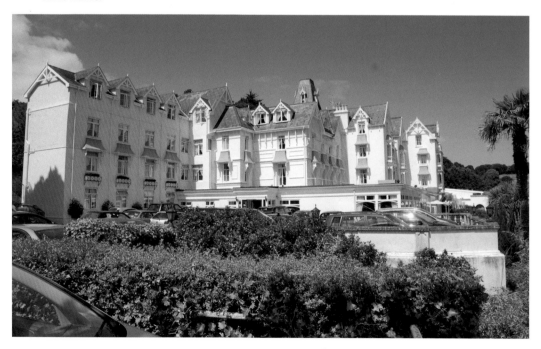

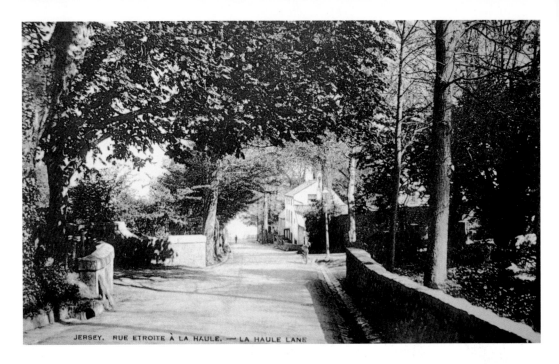

JERSEY. RUE ETROITE À LA HAULE. — LA HAULE LANE

La Haule Lane

Views then (early 1900s) and now (2010) looking down La Haule Lane towards the beach of St Aubin Bay. At the junction where the lane meets the main A1 coastal road at La Haule Slipway, there is now a Sea Sports Centre. Otherwise, very little else appears to have changed over the intervening years. On the right can be seen the premises of both Lucas, the fruit and vegetable merchant, and Le Manoir (de la Haule Hotel).

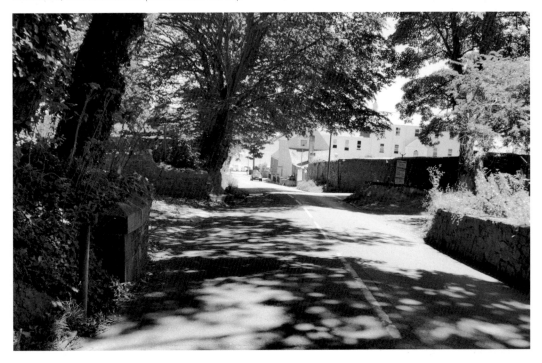

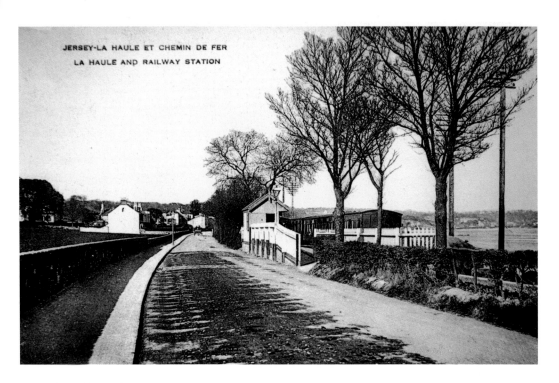

JERSEY-LA HAULE ET CHEMIN DE FER
LA HAULE AND RAILWAY STATION

La Haule Station

The route of the Jersey Railway hugged the coast all the way along St Aubin Bay from the station at St Aubin to the Weighbridge Terminal at St Helier. Le Haule Station, as shown in the pre 1936 photograph, faced the sea with the rail track running parallel to the edge of the beach (originally over the beach on piles). The present pedestrian and cyclist walkway, shown in the 2011 print, follows the route of the old railway line.

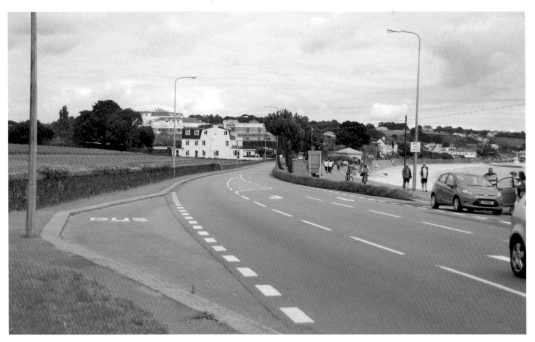

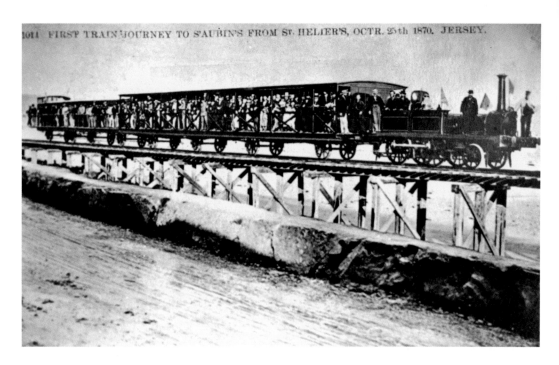

Trains Through Time!

The old photograph, taken on 29 September 1870, captured one of the trial train runs of the Jersey Railway as it 'posed' at La Haule on its return journey to St Helier. The open carriages, the first two of which were built by the Daniel Le Vesconte shipyard, 'Tower Yard', at First Tower, are being hauled by engine *Haro Haro,* one of the railway's first two locomotives. Note the original track was built on wooden piles driven into the beach. By contrast, Le Petit Train *Peirson* was photographed in 2011 at almost the identical spot on its return journey to St Helier.

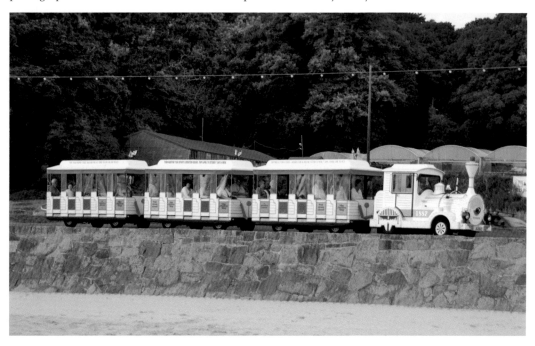

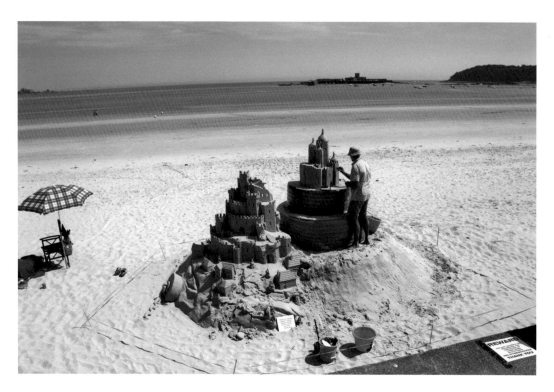

Sand Castles Extraordinaire!

Sand sculpture has been carried out at this spot at La Haule for many, many years and has always attracted a great deal of attention and admiration from passers-by. In this case, Jennifer and Peter Rees from Porthcawl in South Wales chose to have a discussion with the sculptor on his techniques.

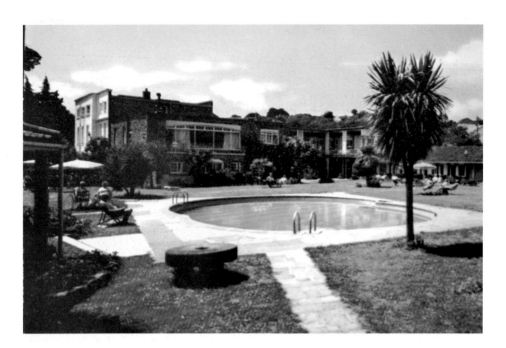

L'Hermitage Hotel, Beaumont

The original setting for L'Hermitage Hotel, was centred on the main building of a large country house and small estate. This building contained the hotel reception, bedrooms, restaurant-cum-ballroom, bars and catering facilities. Expansion had taken place over the years with additional bedroom accommodation being built around the perimeter of the hotel's spacious grounds in Spanish Haçienda style. The main building has again been utilised as Lavender Mews, the centre piece of L'Hermitage Gardens development with only the Apple Press in front remaining untouched as a reminder of the 'good old days' of L'Hermitage Hotel.

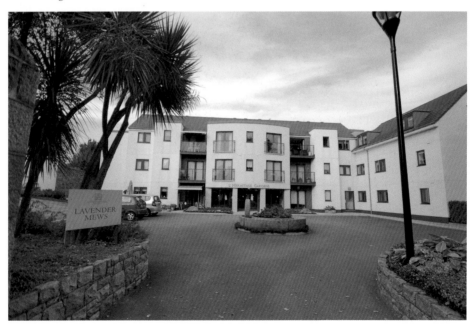

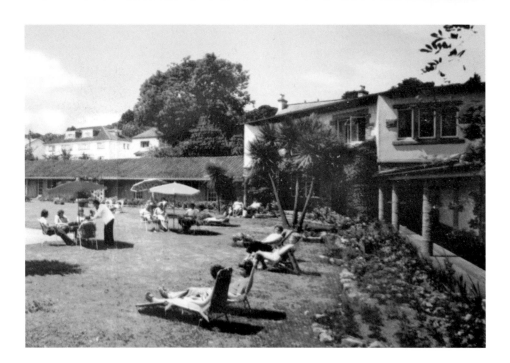

L'Hermitage Hotel, Beaumont

L'Hermitage Hotel, a fine hotel set in its own extensive gardens and grounds with both indoor and outdoor swimming pools, closed its doors at the end of the 2002 season. Planning approval was granted in December 2003 for the building of ninety-nine sheltered units and fifty-one cottages to be erected on the site of the hotel as part of the L'Hermitage Gardens retirement village development. Work commenced in 2004 and has now been completed as illustrated by the photographs taken in 2011.

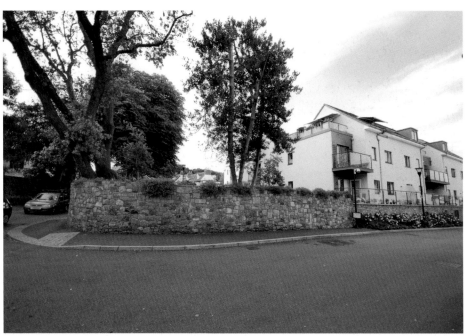

L'Hermitage Hotel and Beaumont Cannon

L'Hermitage Hotel was a popular destination for many couples and groups who regularly spent their annual vacations in the same hotel on Jersey. So much so, that every year during the same period the same people used to meet. Inevitably, friendships developed and they became a 'holiday family'. This relationship extended outside the holidays and led to the development of many long term friendships. The Beaumont Gun, located close to the hotel, was a favourite destination for after dinner walks. Cast for the Parish of St Peter in 1551, it is a falconet and the only example of a parish gun remaining on the island.

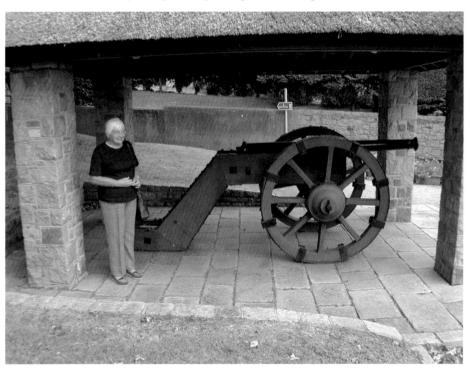

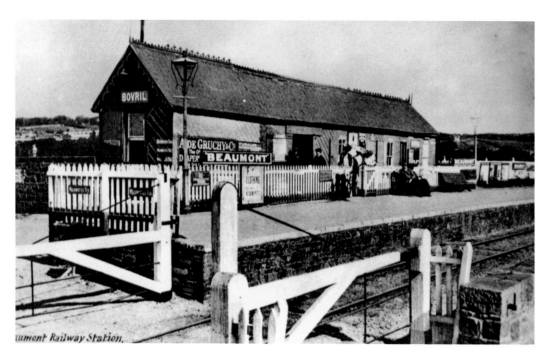

umont Railway Station.

Beaumont Station

Beaumont Station pre-1937 showing the Crossing Gates and now, in 2011, a private residence, which Le Petit Train regularly passes in front of along the old track of the Jersey Railway when it journeys between St Helier and St Aubin.

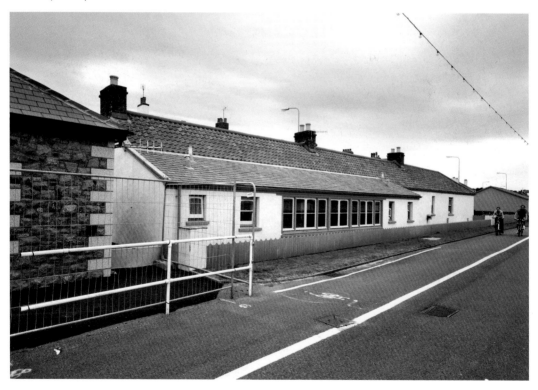

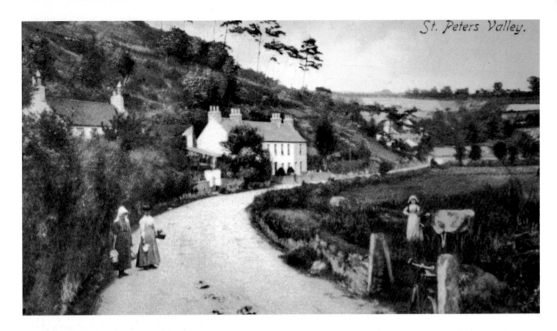

St Peter's Valley

At this point, we take another short diversion from our railway route to travel up the picturesque St Peter's Valley to the German Underground Hospital. Comparing the two photographs taken of the valley, there appears to be little change from the idyllic scene captured about 1900 to that taken in 2010 other than the asphalt road surface and the advent of the motor car.

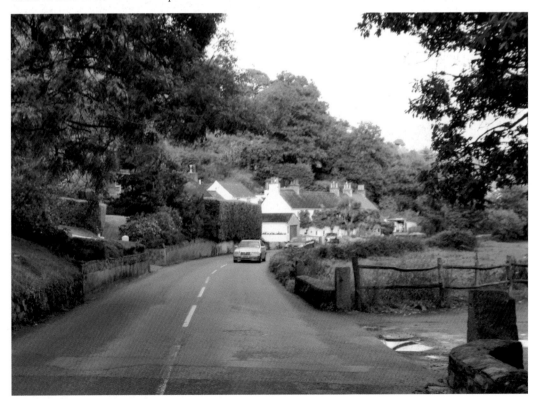

The German Underground Hospital; Jersey War Tunnels

The two photographs were probably taken very soon after the end of the German Occupation when the Jersey authorities first had the opportunity to discover what legacies had been left behind by the occupying forces. The tunnel complex, designated 'Ho8' by the Germans, was built between September 1941 and October 1943 as a bomb-proof munitions barracks. Subsequently between 1943 and 1945, it was converted into an underground hospital.

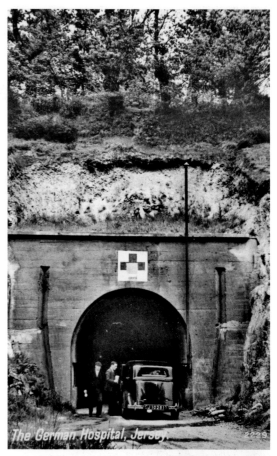

The German Hospital, Jersey.

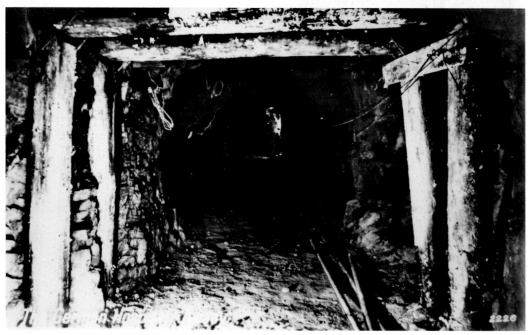

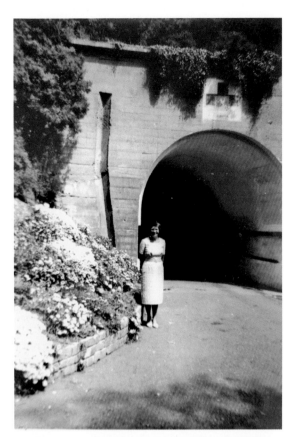

The German Underground Hospital; Jersey War Tunnels

June 1960: a somewhat relieved Malvina Morgan standing outside the entrance to the German Underground Hospital enjoying both the sunshine and fresh air after having just survived a chilly experience inside. Much work needed to be done inside the complex as the tunnels were damp as a result of all the water underfoot, cold due to the bare grey concrete walls and psychologically unnerving because of the knowledge of the terrible conditions under which the slave labourers had been forced to work in its construction.

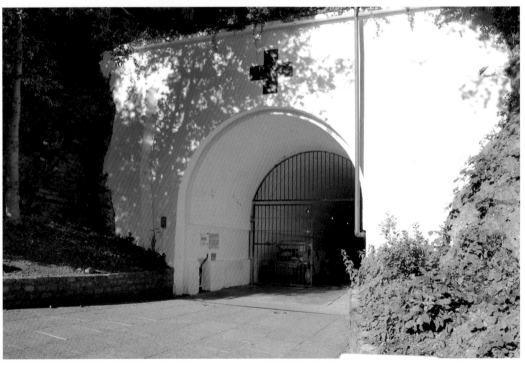

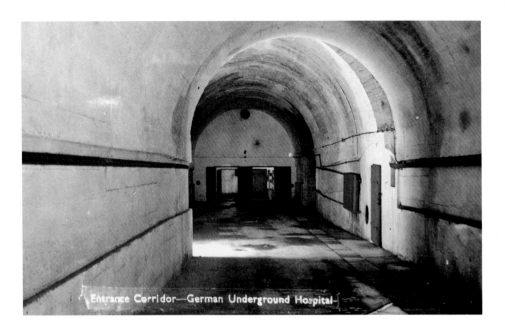

Entrance Corridor—German Underground Hospital

The Jersey War Tunnels

The Jersey War Tunnels, as they are called today, are a far cry from 1960. At that time, the German Occupation was still fresh in the memory of the island's inhabitants, and the potential that the relics left behind by the occupying forces would one day form part of Jersey's rich heritage, was only just beginning to be realised. This has now come to pass. The tunnels shown in the 2011 photographs are dry; they have pristine white painted walls throughout and serve as both a Museum to the German Occupation and a Memorial to those who suffered during this dark period of the island's history.

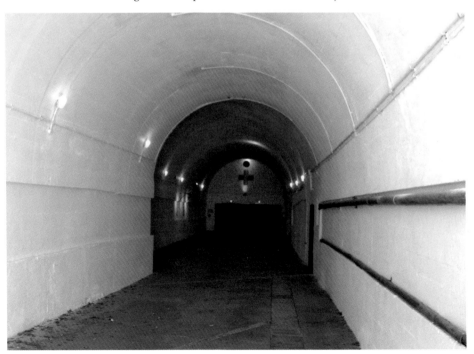

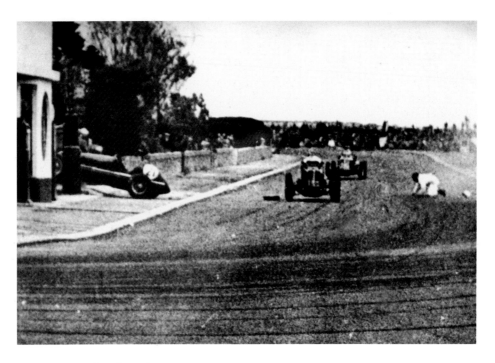

Jersey International Road Races

Returning to the route of the old Jersey Railway, we look back in time to 1948 in the top photograph where S. J. Gilbey parted company with his car at Marquand's Corner, Bel Royal, during the Jersey International Road Race of that year. Also at Bel Royal, the second photograph captures A. A. Baring (Car No. 22) and J. Bolster (Car No. 12) leading the field round the corner of the Bel Royal Garage in the 1951 Jersey International Road Race.

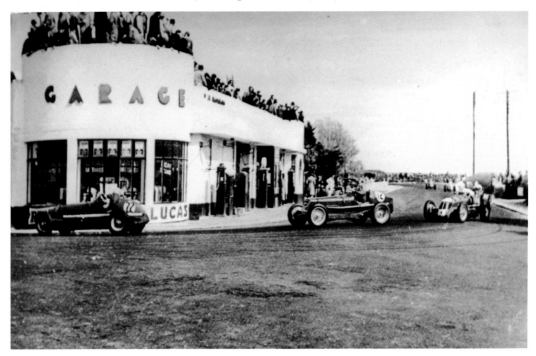

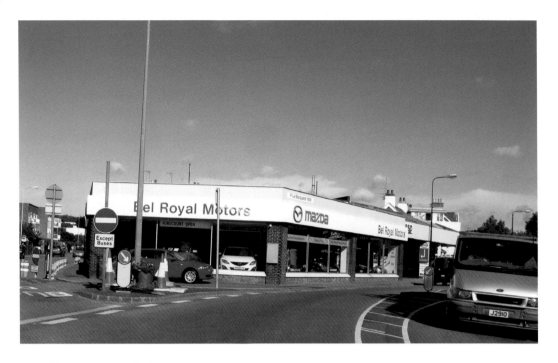

Garages, 1930s-Style

Garages in the 1930s had a distinctive look about them. The Bel Royal Motors garage of today has, unfortunately, lost its rather classical rounded corner showroom bay window as captured in the photograph on the previous page. However, the Full Service Garage of First Tower, a few miles further down the road towards St Helier, still retains its distinctive 1930s style architecture as shown in the 2010 photograph. This type of garage still forms the design basis for toy garages manufactured for little boys to play with that have a ramp to enable model cars to be pushed to the top floor.

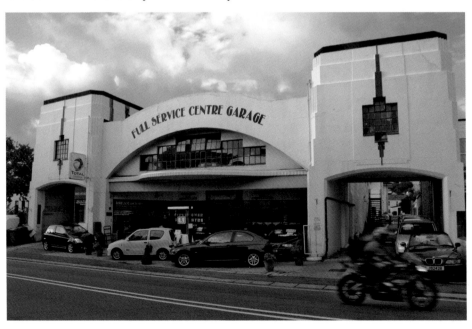

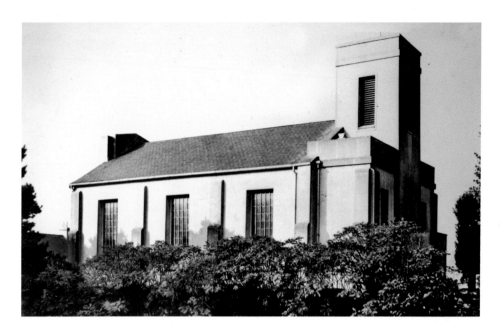

The Glass Church

Built in 1840, St Matthew's Church at Millbrook is famous throughout the world for its glass-work. Externally dull; inside a remarkable world of glass is revealed. Not just any glass, but masterpieces created by French artist René Lalique between 1932 and 1934 for Lady Trent, Florence Boot, as a memorial to her late husband Baron Trent, Jesse Boot, founder of the 'Boots the Chemist' chain. The two photographs show the original structure and the major restoration work that has been going on since 2004.

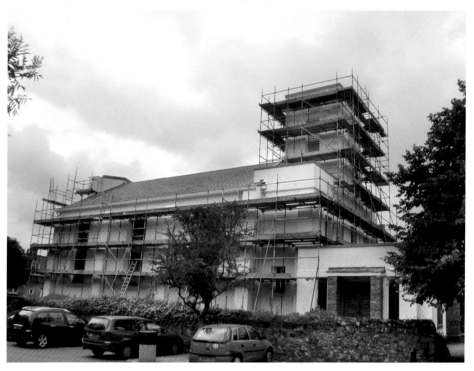

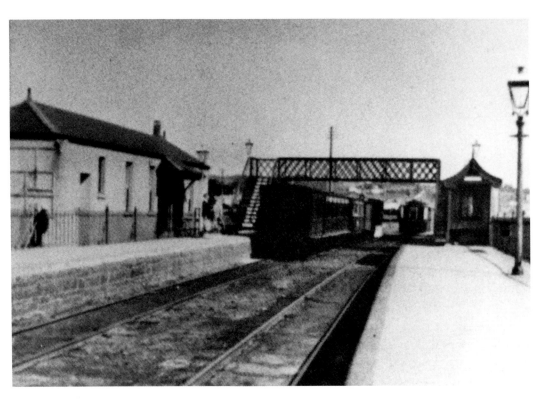

Millbrook Railway Station
Two views of the station in its heyday pre 1937 and in 2011 as the Old Station Café.

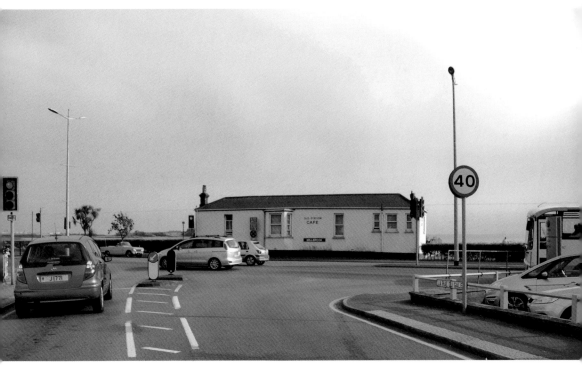

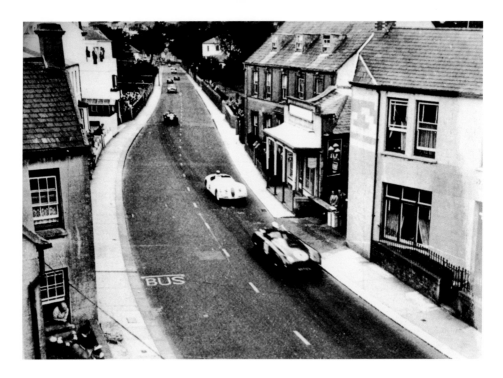

Inner Road Near Farley's Yard, First Tower

Following the same closed loop circuit course as the International Road Races, Sports Car Racing was also held in the immediate post Occupation years. The circuit of just over 3 miles, ran on the public highway from the Grand Hotel along the coast road (A2 – Victoria Avenue) as far as Bel Royal and then returned on the Inner Road (A1 – St Aubin's Road) through Millbrook and First Tower back to the Grand Hotel. The present day photograph of 2011 shows a much more leisurely mode of travel.

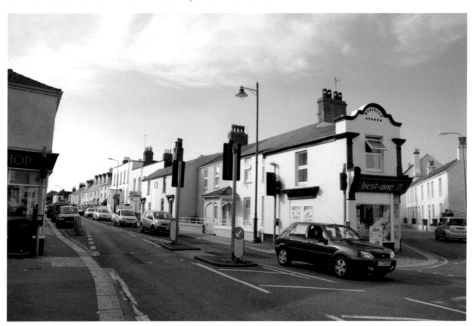

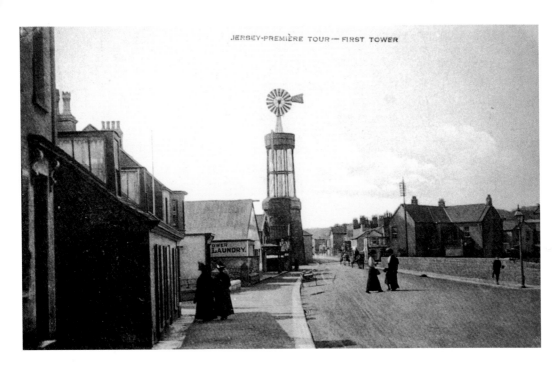

First Tower

Again, two contrasting photographs that highlight the changes which have taken place over time with the mode of transportation. From the horse and trap of the late 1800s to the sophisticated airport double-decker buses, introduced in 2011. The water tank with its 'Climax Wind Pump' perched above have long gone from the top of the Martello Tower, but the tower itself still remains.

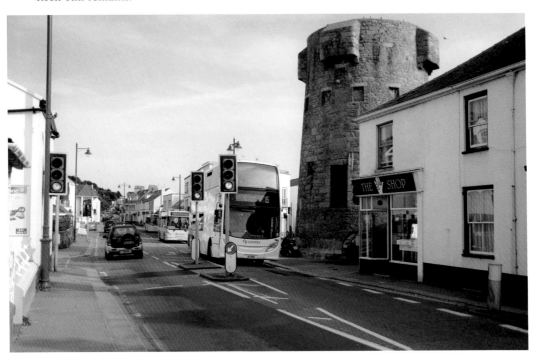

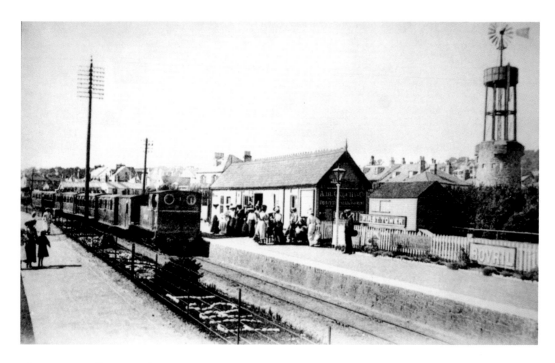

First Tower Railway Station

Like the Climax Wind Pump and its accompanying water reservoir tank, the station has long gone, giving way to a wide roadway highlighted by the passing of a 'Bedford OB Bus' of *Classic Coaches.* Note the garden in the forefront of the pre 1937 railway photograph, which runs parallel to both track and platform, and spells out First Tower Station in flowers.

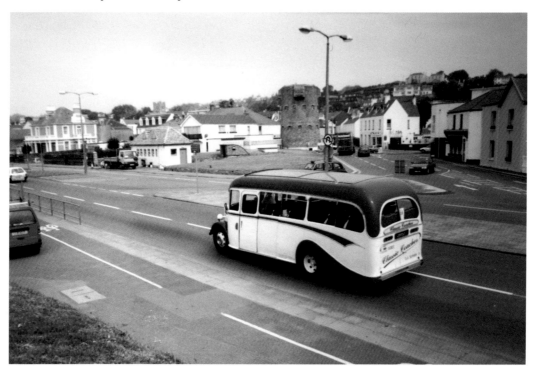

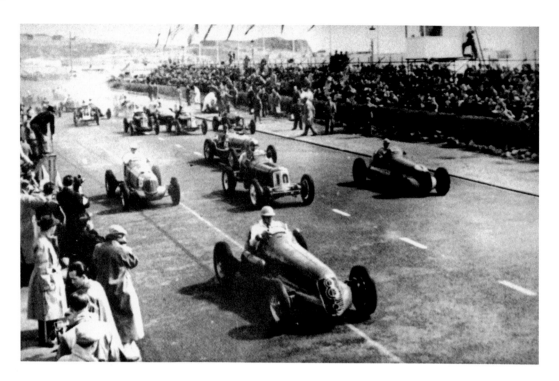

Start of the 1948 Jersey International Road Race
One of the many motor racing and railway photographs provided by the Pallot Steam, Motor and General Museum for this book. At the end of the Second World War, Jersey was selected as the venue for the British Grand Prix and races were held here from 1947 to 1952. The top picture shows the competitors accelerating along Victoria Avenue after the start of the 1948 Jersey International Road Race. A far cry from the 2011 Battle of Flowers where the Trinity Parish Super Heroes Float is making its way westward along what is now a dual carriage way, Victoria Avenue.

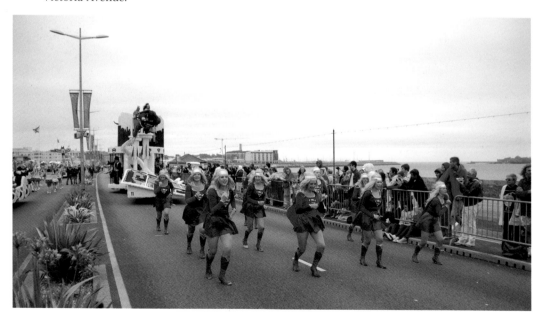

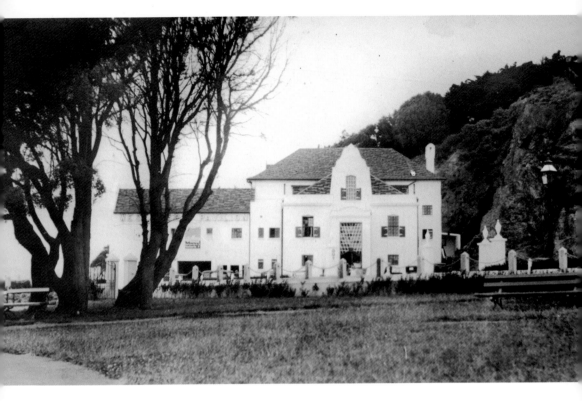

West Park Pavilion, pre 1999
As the 'Inn on the Park', the 'Pav', as it was affectionately called, closed for good in 1966. It was finally demolished in 1988/99 to be replaced by a luxurious apartment block shown under construction in September 2005.

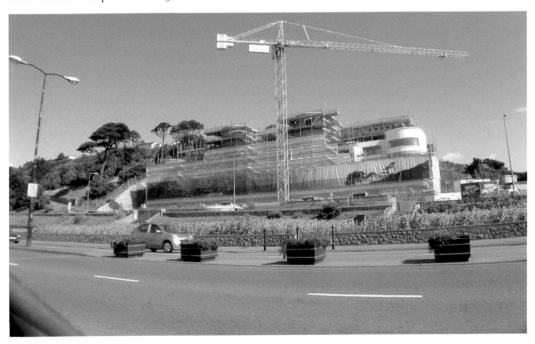

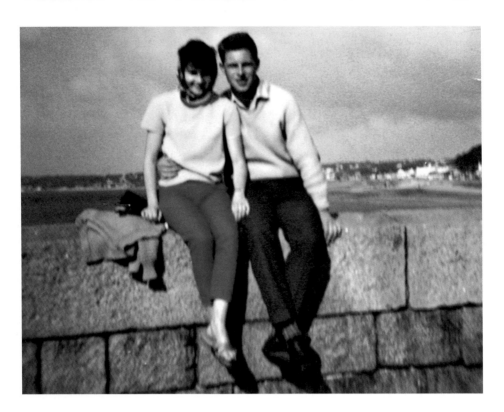

The Jersey Wall

Gaynor and Gerald Davis of Cefn Cribwr, Bridgend, South Wales, were married in September 1963 and honeymooned in Jersey. Where else? They still holiday in Jersey and in the 2011 photograph, they tried to emulate the same snap shot taken of them on the Jersey Wall in 1963. They could find the same background view of St Aubin's Bay, but not the exact spot on the wall. What's more, they both found it more difficult to get to a sitting position on it than they previously did! This is where the reader leaves the Jersey Railway and pays a visit to Elizabeth Castle before joining the Jersey Eastern Railway.

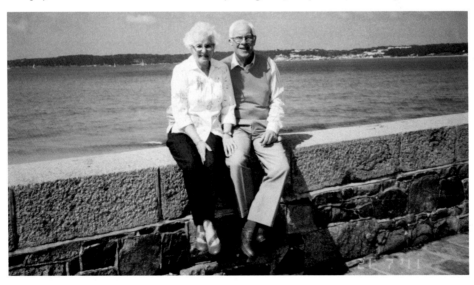

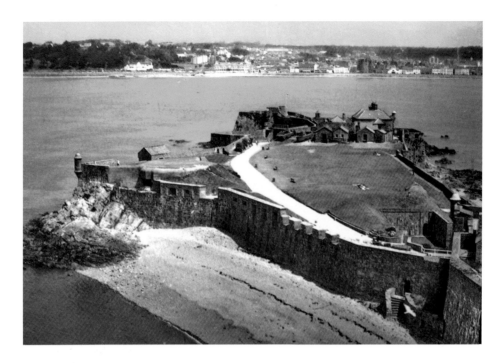

Elizabeth Castle

The initial part of Elizabeth Castle was built between 1594 and 1601 with periods of sporadic extension work being subsequently carried out until 1806, when the foundation stone was laid for Fort Regent. It was Sir Walter Raleigh, Governor of Jersey in 1600 who 'presumed to christen the new castle Fort Isabella Bellissima'. Sisters Jacqueline and Malvina are overlooking the lower ward of the castle while the inset features one of the traditions of the castle; the firing of the Midday Gun.

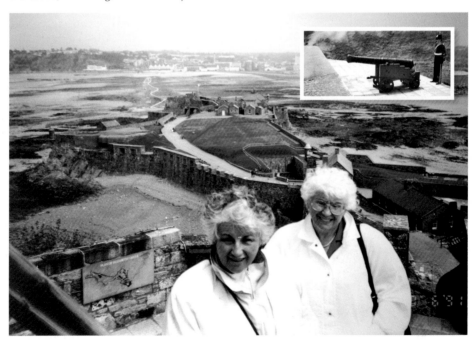

Havre des Pas Route of 60 cm Narrow Gauge Occupation Railway 1943 and post-1946

Following our short excursion to Elizabeth Castle, we now join the route of the old Jersey Eastern Railway. From the St Helier Snow Hill Terminus behind Fort Regent, this line followed the coast all the way to Gorey Harbour. It ceased operation on 21 June 1929 and the track was recovered less the station buildings. During the Occupation, and with their line running from the harbour at St Helier, the Germans laid a 60 cm narrow gauge mineral line along the route of the old Jersey Eastern Railway to link St Helier to Gorey. All the German railway lines were dismantled in 1945/46.

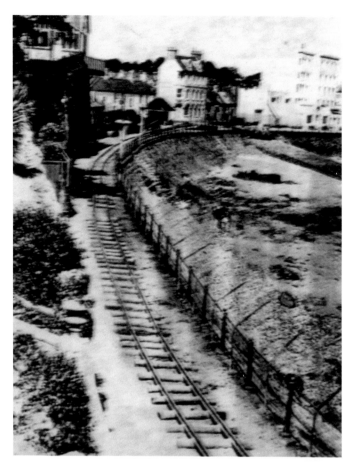

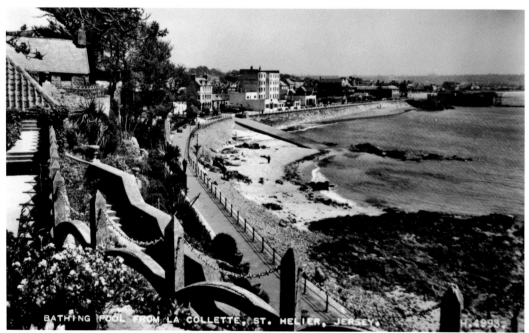

BATHING POOL FROM LA COLLETTE, ST. HELIER, JERSEY.

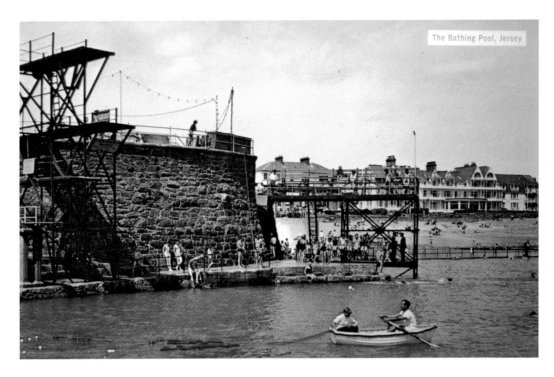

The Bathing Pool, Jersey

The Swimming Pool Havre des Pas in the 1930s and 2011

The Swimming Pool, a big attraction at Havre des Pas in the 1930s and post-Occupation and before the Health and Safety Regulations put an end to diving boards. The complex is now called the Havre des Pas Lido.

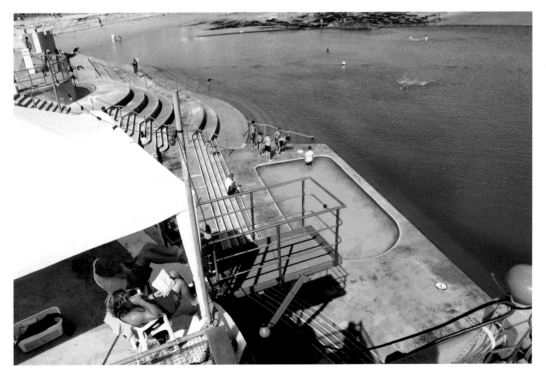

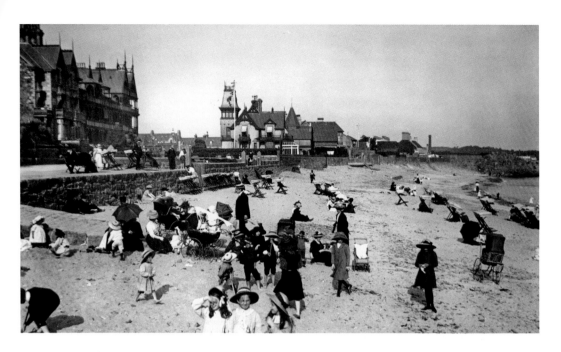

The Beach and Promenade at Havre des Pas, Early 1900s and 2011

Havre des Pas beach has always been a popular recreational spot for holiday makers and locals alike. The rather sombre attire worn by the sun worshippers in this view of the beach looking towards Dicq, helps to date the black and white photograph to pre-First World War. Still a magnet for holiday makers, this stretch of promenade boasts a number of boarding houses and hotels including the prestigious Ommaroo Hotel at the far end on left and Hotel De Normandie at Dicq.

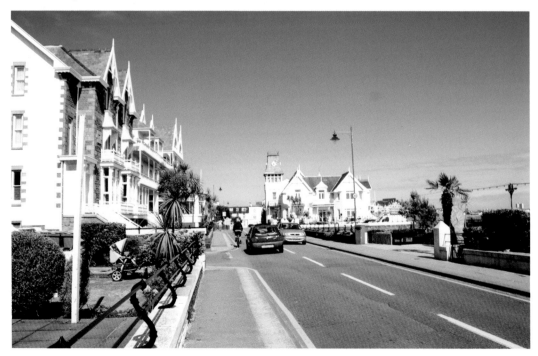

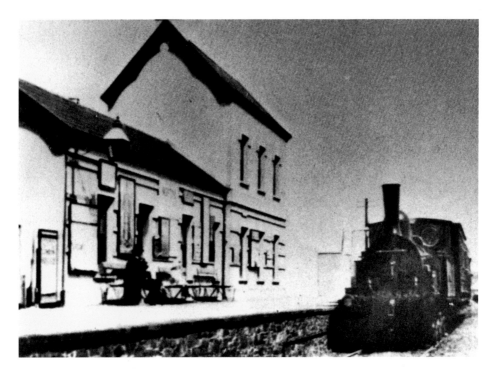

St Luke's Railway Station pre 1929 and the Site in 2011

The railway station buildings on the standard gauge (4 foot 8½ inches), Jersey Eastern Railway followed a standard and unique pattern with each being substantially built of stone and their architecture closely resembling that of Normandy wayside railway stations. Each station characteristically had a two storey Station Master's House with a single storey ticket office and waiting room butted on and in line alongside. This design has been attributed to the influence of the Jersey Eastern Railway Engineer, Hammond Spencer, who was a pupil of Monsieur Buddicom of Rouen.

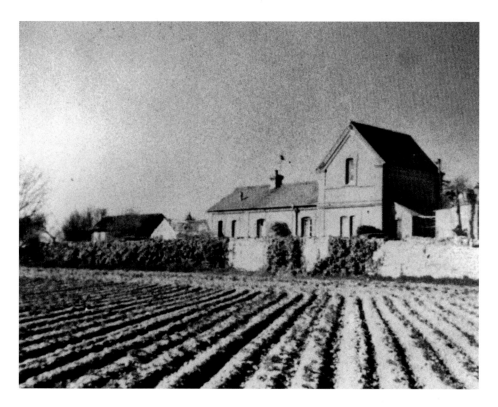

Samarès Railway Station

Two views of the old Samarès Railway Station, which was opened in 1873, where one cannot fail to recognise the distinctive Normandy style architecture of the Station Master's House and ticket office/waiting room alongside. The latter photograph of 2011 shows the building development that has taken place alongside the old station.

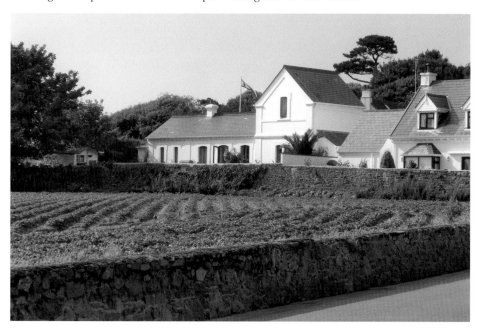

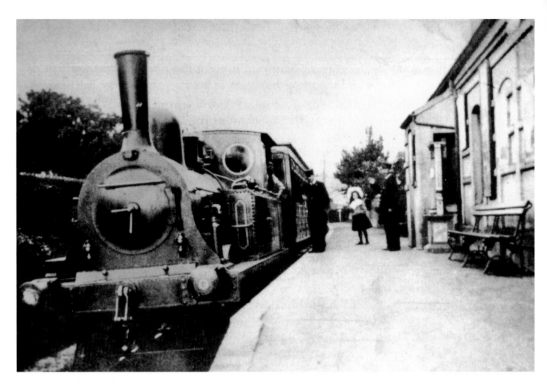

La Hocq Railway Station 2½ Miles From Snow Hill, St Helier, pre 1929

The engine standing at the platform is the 0-4-2T *Carteret* hauling an up train *en route* to St Helier. In contrast, a charabanc is captured on film at La Hocq as it makes its way in the opposite direction to Gorey Harbour on 30 June 2011, while the image from the Denis Holmes collection shows two manual Fire Engines manned by Paid Police (the forerunners of the St Helier Fire Brigade), at roughly the same spot in 1880.

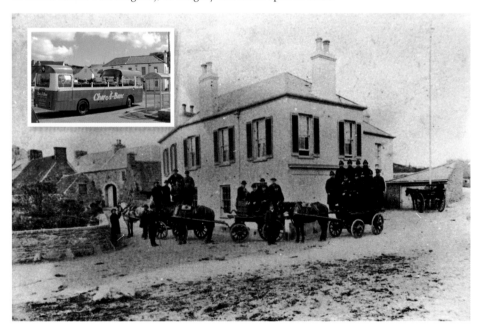

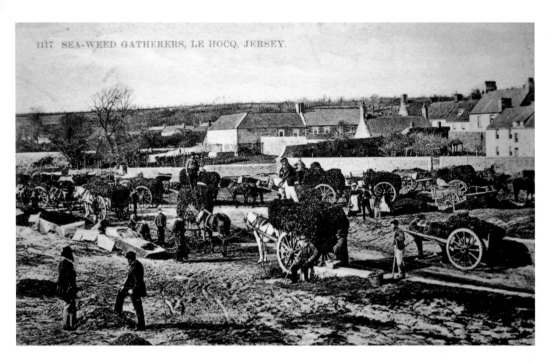

Seaweed Gatherers at La Hocq Early 1900s

Known locally as *vraic,* farmers collected the seaweed from the seashore to spread on their fields as fertiliser. The practice is still carried on today around the coast in many parts of Jersey. The view of the *vraic* gatherers was taken on La Hocq common sometime in the 1900s. Today, this site is occupied by St Clement's Parish Hall as shown in the 2011 photograph.

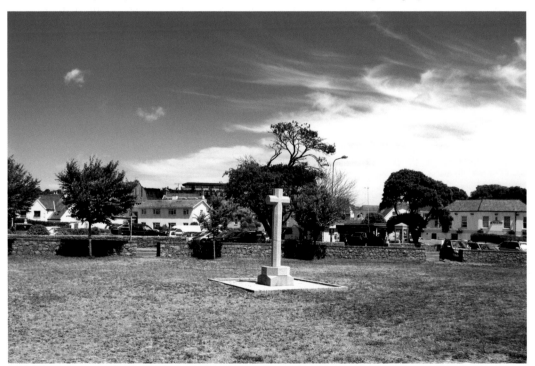

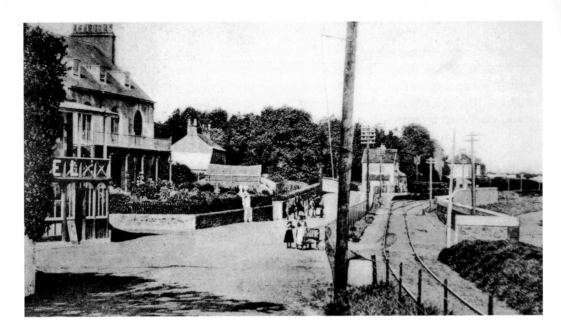

Pontac Railway Station, Early 1900s

Possibly taken in the early 1900s, this view shows the seafront at Pontac with the track of the Jersey Eastern Railway running parallel with the main coast road. The Pontac Hotel is on the left and the station can be seen in the background with a down train for Gorey waiting to depart. Pontact was a popular station for excursionists travelling to the concerts held in the nearby gardens. In the close up, we have Station Master McQueen with his wife Sarah Lucy Jane.

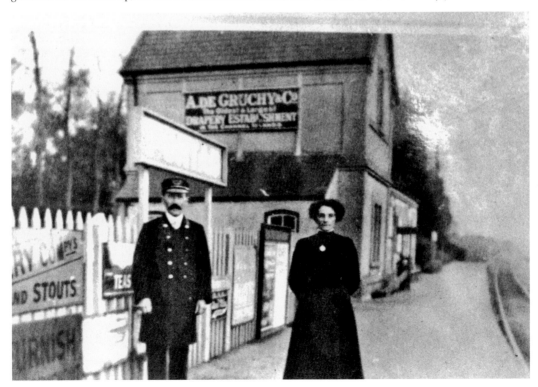

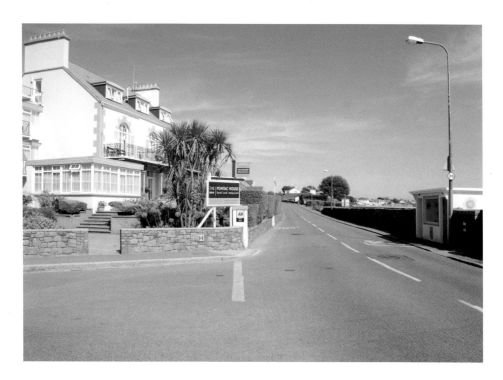

Pontac and La Bourg Stations

The Pontac Hotel is still in business, but nothing remains of Pontac Railway Station as can be seen in the 2011 photograph. Le Bourg, an intermediate station just ¾ mile beyond Pontac, was opened on 12 March 1925 following years of petitioning by local inhabitants for a station to serve their locality. The picture captures locomotive 0-4-2T *Calvados,* bedecked with Union Jack flags and waiting to return to St Helier with a three-coach special train after the ceremony. The latter was carried out by Jersey Eastern Railways Director C. B. Buttfield in the absence of the Lieutenant Governor.

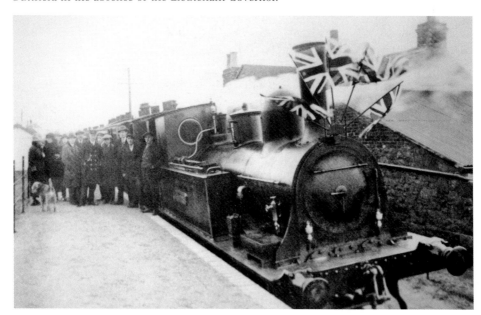

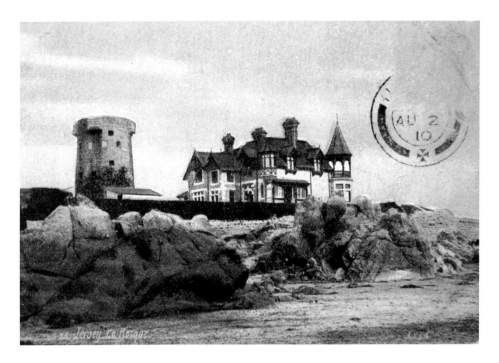

La Rocque Point 1910 and 1992

La Rocque Point; a distinctive location in Jersey's colourful history. Sisters Malvina and Jacqueline are admiring the blue plaque, which records that the French came ashore on 6 January 1781 under the command of Baron De Rullecourt. The same day, the Battle of Jersey was fought in St Helier town square resulting in the defeat and last invasion of the French, but also resulting in the deaths of both the Baron and, hero of the day, Major Peirson, commander of the Jersey Regulars and Militia.

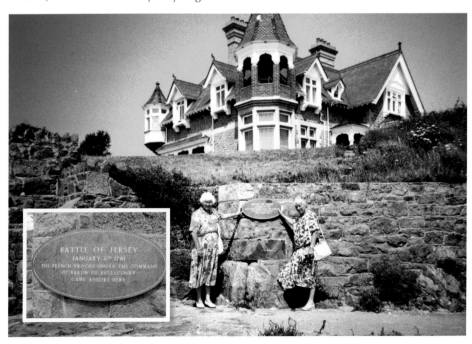

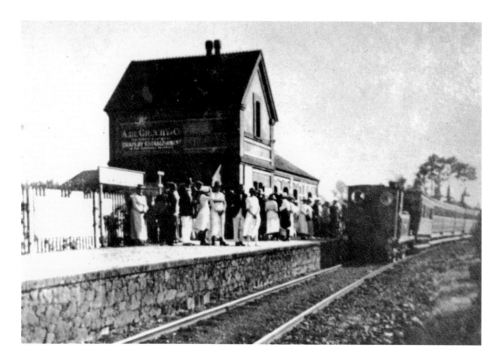

La Rocque Railway Station

La Rocque Station was located just 4 miles from the terminus of the line at Gorey Harbour and within sight of Mont Orgueil Castle. A very busy intermediate station as can be seen in the photograph where a six-carriage train is waiting to take a platform full of passengers on to Grouville and Gorey. Saturdays were exceptionally busy in the years before the First World War when fisherwomen loaded their barrows on the first up train for the market at St Helier. The 0-4-2T *Calvados* engine is a typical of the locomotives employed on the Jersey Eastern Railway.

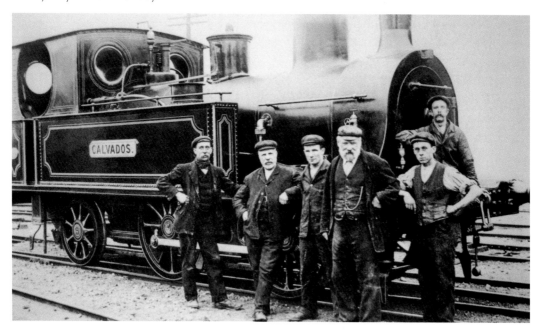

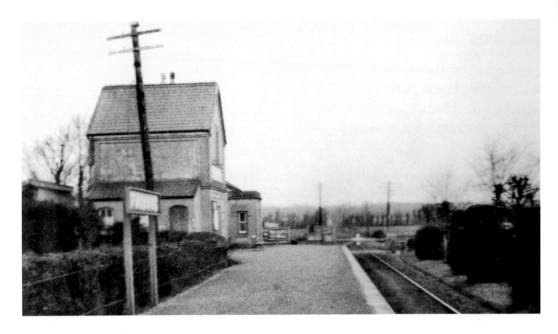

Fauvic Railway Station

Known as Les Marais Station until 1904, it was renamed 'Fauvic' to avoid confusion with the similar sounding Samarès. Taken after 1904, this view looking towards Gorey Pier shows the level crossing gates, which were operated by the station staff, and the long straight section of railway line stretching beyond towards Grouville, the next station on the line. The buildings of the former Fauvic Railway Station are still recognisable in the photograph of 2011 even though extensive development of the property has taken place.

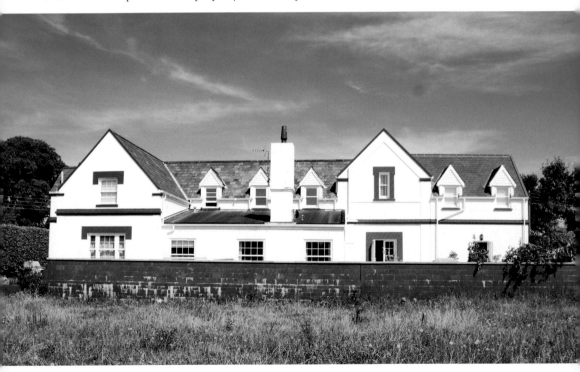

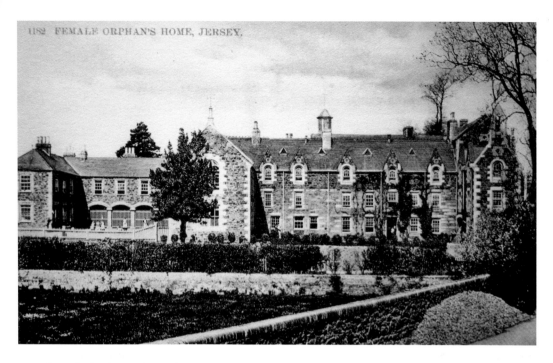

Female Orphans Home, Jersey, c. 1920
Located not far off the route of the Jersey Eastern Railway at Grouville, was the Jersey Female
Orphan's Home. This was founded by Abraham Le Sueur, Rector of Grouville Parish Church, in
September 1862. It was finally closed in 1959 and subsequently demolished to make way for a
building development called Le Clos de L'Eglise.

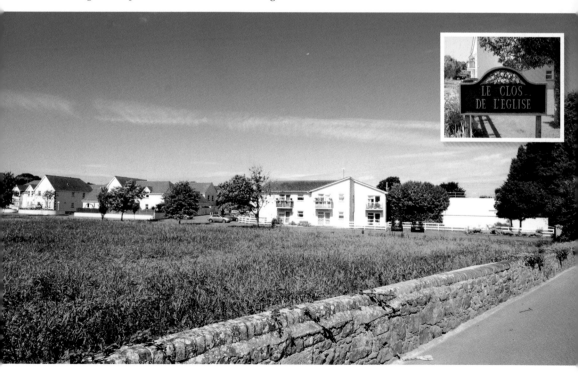

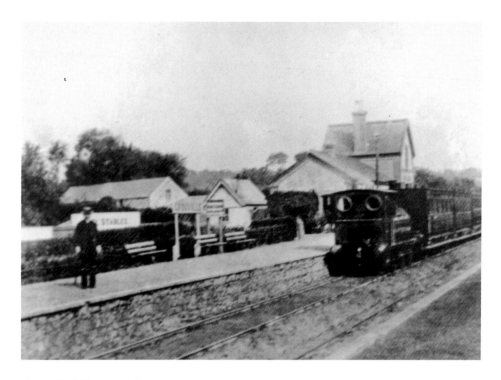

Grouville Railway Station

The station at Grouville was opened in 1873. The picture, taken about 1906, shows an east facing view of the station looking towards Gorey with 0-4-2T locomotive *Mont Orgueil* arriving, pulling an up train made up of five carriages. This station served the Royal Grouville Golf Club and it was the only station on the Jersey Eastern Railway to have a footbridge (not visible in photograph) to give access to the main road and golf course. The station buildings are still clearly defined in the 2011 west facing view even thought development of them has taken place.

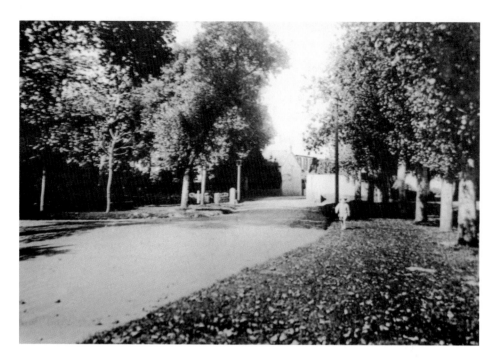

Entrance to Gorey Village

This entrance now only serves part of Gorey village directly due to the one way traffic restrictions that apply through the old village main street. It was also the road access point for the Jersey Pottery which finally closed its doors for good in January 2012 to make way for housing development. Entry to the village itself is about ¼ mile further along the main road, past the cart spilling over with flowers and opposite the old Gorey Village Railway Station.

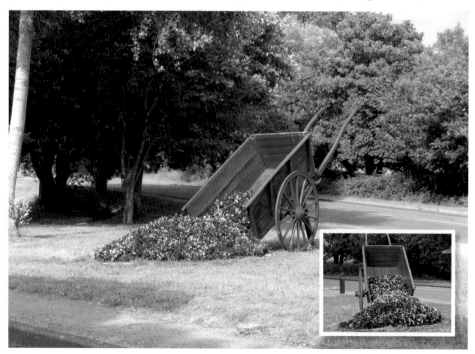

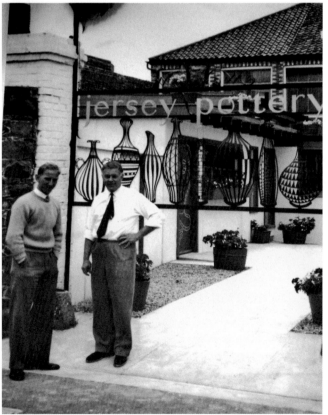

The Jersey Pottery in 1954
The original Jersey Pottery, which was set up by Charles and William Austin Potter in 1946, was bought by Clive and Jessie Jones in 1954. Jersey's tourism industry was developing at that time and they saw the potential to establish what was to become one of the island's most popular tourist attractions. This was done by making all stages in the production of the pottery viewable by the customers.

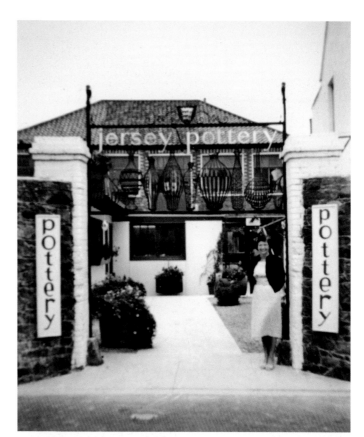

The Entrance to Jersey Pottery from Gorey Village

The two views show Malvina Morgan outside the entrance to the Jersey Pottery from the main village street in June 1960 and June 2007 after the entrance was redeveloped.

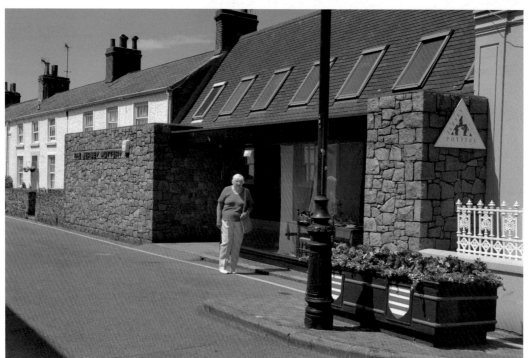

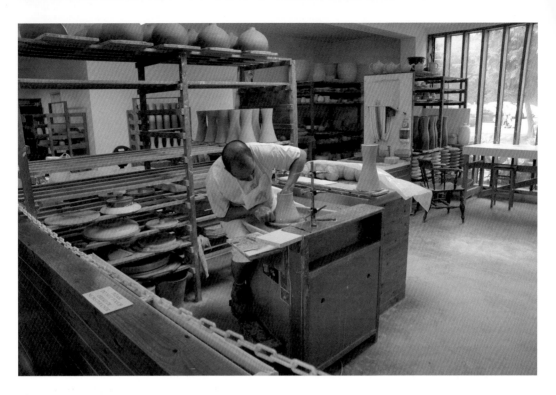

The Jersey Pottery
Two views taken in 2007 that respectfully show the throwing and decorating of pottery. Jersey Pottery has a distinctive look all of its own and has now become 'collectable'.

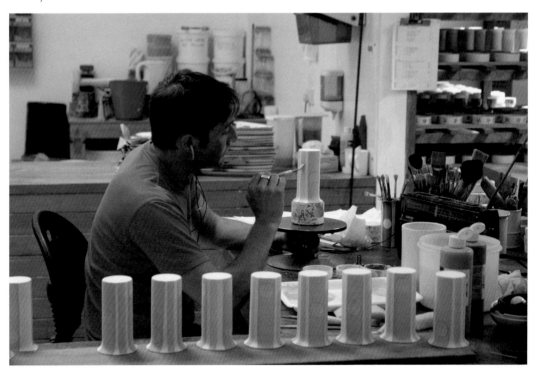

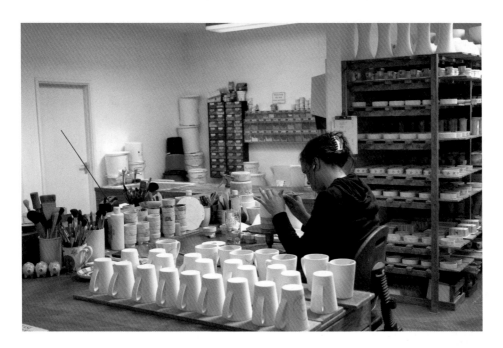

The Jersey Pottery

Again, two views taken in 2007 that respectfully show an artist applying the decoration to pottery pieces before they are glazed and finally fired in the kilns. The inset of 2011 shows a novel new venture, which was introduced in 1998. This was called *Glaze Craze* – a unique 'hands-on, do-it-yourself' painting studio where visitors could paint their own pot and then have it glazed and fired ready for collection a few days later.

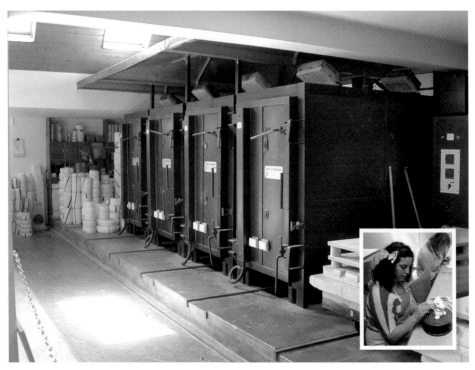

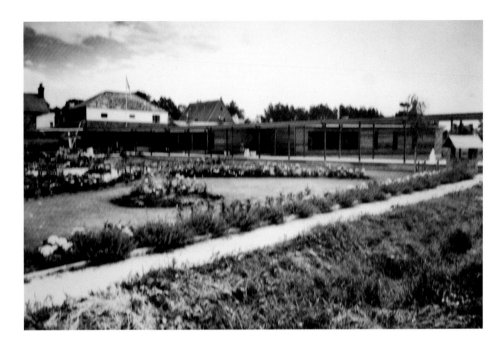

The Jersey Pottery Gardens

By 1960, 4 acres of land behind the pottery were leased. This allowed the buildings to be modernised, a new showroom built, gardens laid out and sufficient car parking provided at the rear of the pottery to cater for the increase in the number of visitors arriving both by car and coach and as a result, relieve the congestion in Gorey Village itself. The photographs of the gardens were taken in 1964 and 2004.

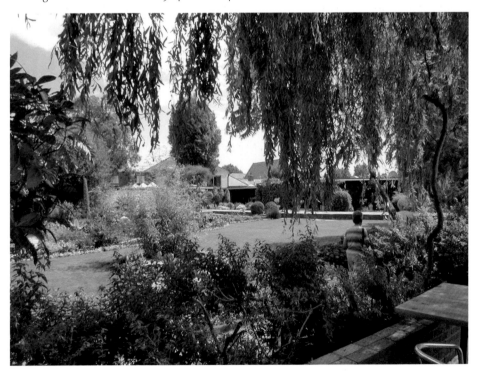

The Jersey Pottery Restaurant, Gorey Village

Built in the 1970s, the restaurant offered a choice of terrace or indoor seating for up to 500 customers. Specialising in seafood dishes and exotic sweets as shown in the first photograph, it soon established a reputation for good food and service. Under the management of Italian *maître d'* Franco Frezza, the fame of the restaurant spread with celebrities like John Inman visiting the venue. Robert Jones, grandson of Clive, joined the restaurant business in 1988 and his sister Gemma joined in 1990 when further development took place. Sadly the restaurant closed in 2007/08 followed by the Pottery in January 2012.

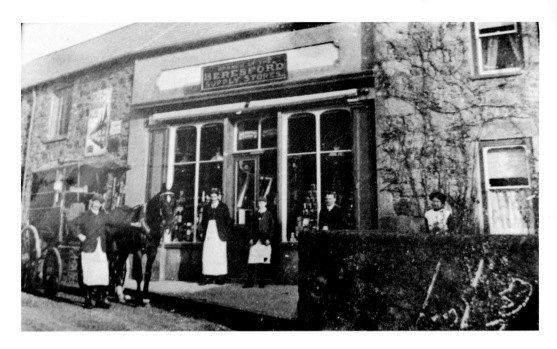

Rosedale Stores, Gorey Village *c*. 1907 and 2011

Little has changed with this Gorey Village shop between 1907 and the present day other than the name. The shop in the old photograph proudly proclaims that it is a Branch of The Beresford Supply Stores. Today, the shop is called the Rosedale Stores and is owned by Pat Clarke who is standing in the shop doorway in the photograph taken in 2011. Pat has worked in the stores since 1955 when she left school. She took over the business in October 2000 and has been running it successfully ever since.

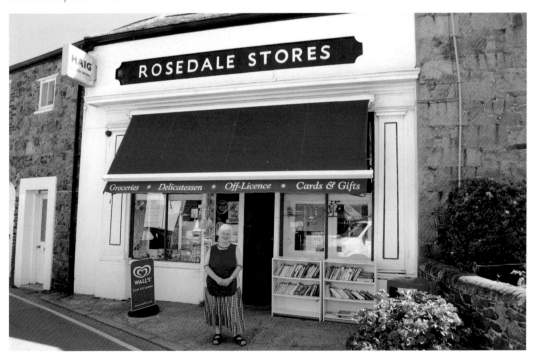

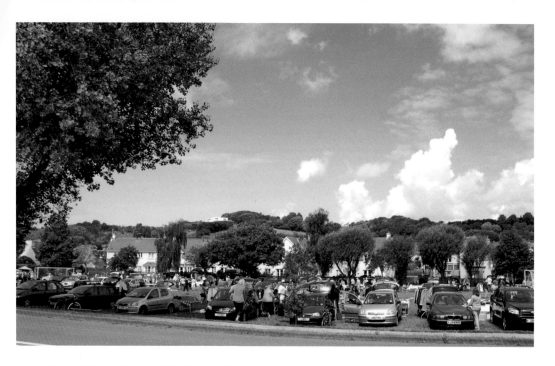

Gorey Village Green – The Jersey Revels

The Village Green becomes a hive of activity when a Car Boot Sale is held there every other Saturday morning. In June 2004, it was especially busy when it was taken over for the Jousting Arena of the Jersey 1204–2004 Revels. The biggest event of its kind ever to take place in Jersey, the Revels were part of the 800th anniversary celebrations held on the island. The year 1204 was a defining point in Jersey's history when it chose to be loyal to the English Crown rather than pay allegiance to the King of France.

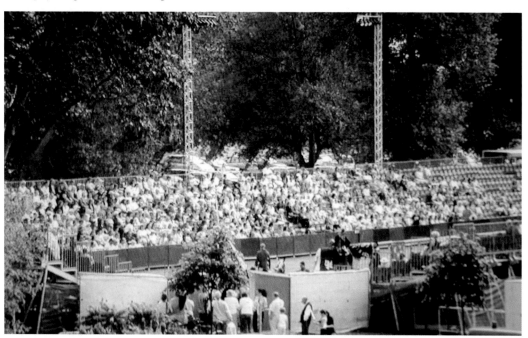

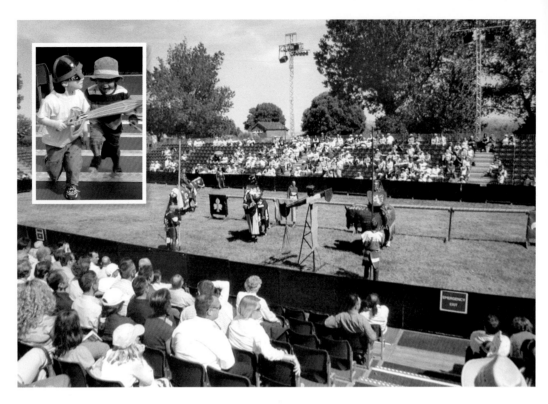

The Jersey Revels 1204-2004
A colourful show of medieval splendour took place in the Jousting Arena at Gorey Village where knights decked out in shining armour and displaying their brightly coloured heraldry, fought each other on horseback in defence of their lady's honour. It did not take much for youngsters to follow suit as shown in the inset.

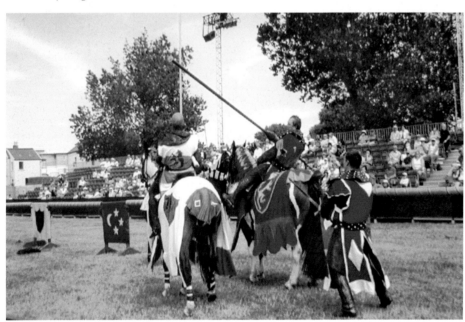

Gorey Village Medieval Encampment, June 2004

The public car park in front of the Old Court House Hotel was taken over as a Medieval Encampment. This is another colourful sight with everyone dressed in medieval costume and demonstrating what life was all about in 1204.

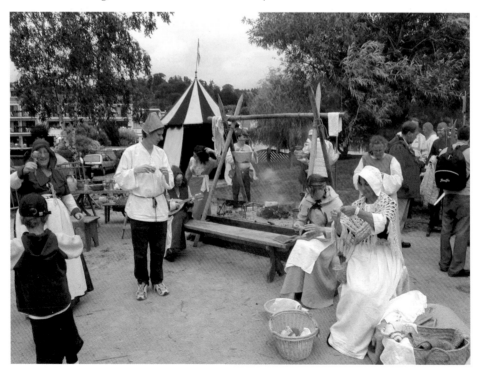

85

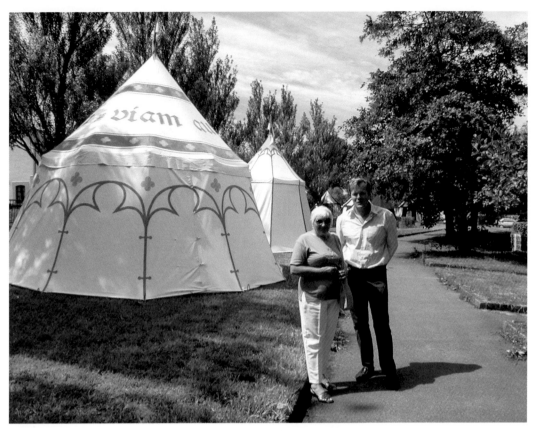

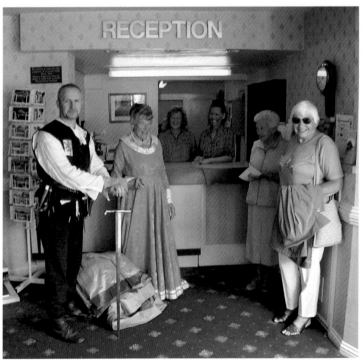

The Knights
Encampment and
Visiting Royalty at
Gorey Village, June
2004
Damsel and Knight
(holiday maker
Malvina Morgan and
local Knight Robert
Jones of the Jersey
Pottery), meet at the
Tents of the Knights
Encampment, while
visiting 'Royalty'
are checking in
for a good night's
accommodation at
the Old Court House
Hotel.

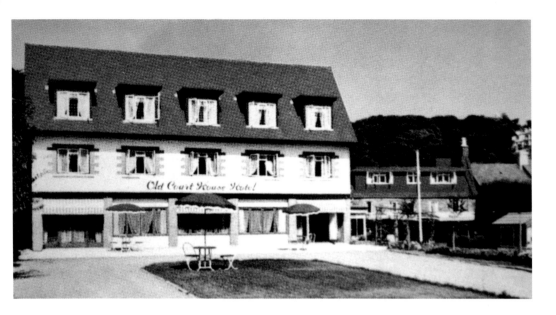

The Old Court House Hotel, Gorey Village, 1967

Part of the hotel restaurant is reputed to be fifteenth century when it was supposedly the District Court House used for the claiming and disposal of admiralty prizes – the sale of ships captured by privateers who sailed from Gorey harbour. The hotel has been extended many times, but the original low oak-beamed ceilings and open granite work have been carefully preserved. The hotel was captured on film by a couple who spent their honeymoon here in 1967 and brought the photographs with them from Australia when they stayed again in 2010. The date of the fire appears to be a mystery.

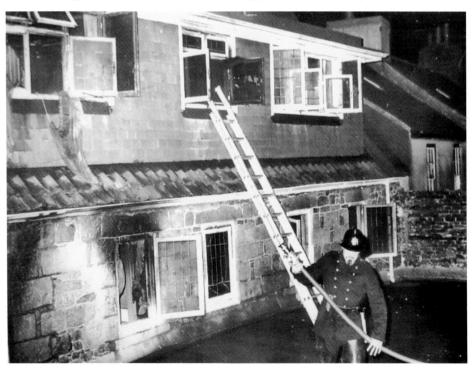

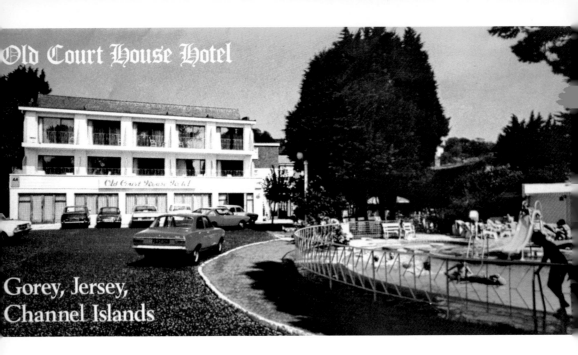

Old Court House Hotel

Gorey, Jersey, Channel Islands

The Old Court House Hotel, Gorey Village
The two photographs serve to show the development of the Old Court House Hotel that has taken place since 1967 when you could stay at the hotel in a double room with full board for £4 16s 0d a night! The full extent of the Old Court House Hotel as it is today has been captured in the 2010 group photograph of management and staff with nature, in the form of a beautiful cloud formation, providing the perfect backcloth.

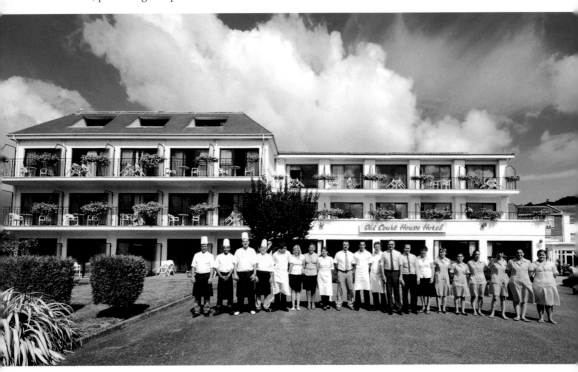

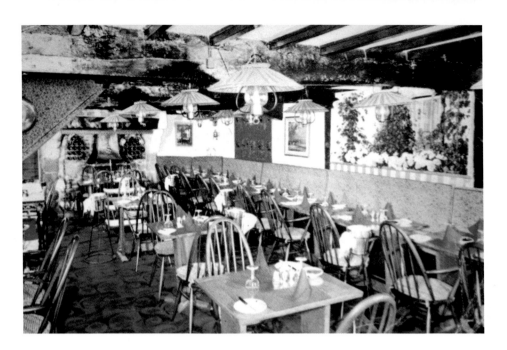

The Restaurant at The Old Court House Hotel
The atmosphere of the fifteenth-century original features and structure has been carefully maintained in the two photographs taken of the restaurant at the Old Court House Hotel, Gorey Village, in 1967 by the Australian couple and the author in 2010.

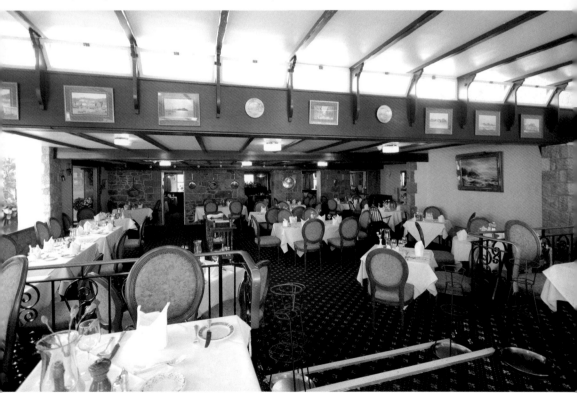

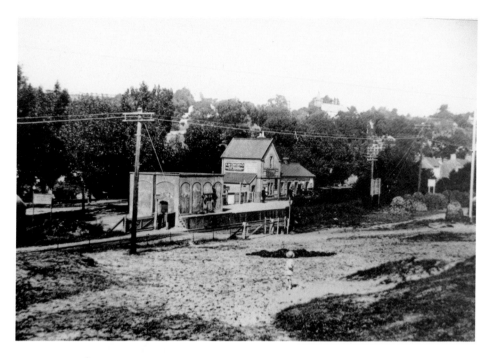

Gorey Village Station *c.* 1906 and 2011

Two views of Gorey Village Station from the seaward side. Opened in 1873, it was for eighteen years the terminus of the line and called Gorey Station. It was re-named in 1891 when the Jersey Eastern Railway extended the line as far as the new terminus at Gorey Pier. Gorey Station had a water tank house and adjacent water crane which were added some time after the railway opened. Both the station and water tank house still remain, but have been converted into private dwellings.

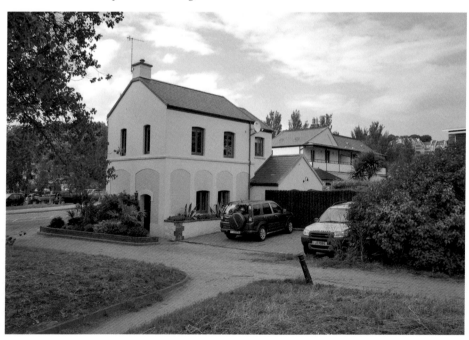

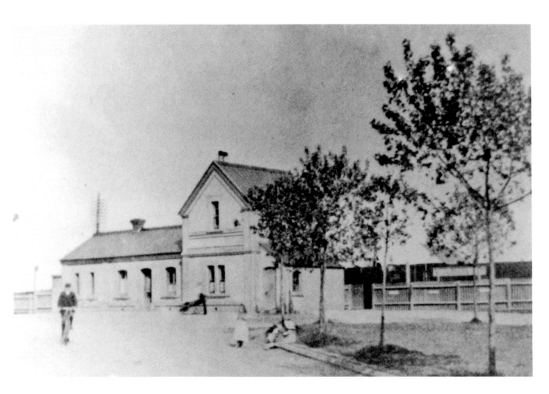

Gorey Village Station *c.* 1906 and 2011
Two views of Gorey Village Station, this time from the landward side.

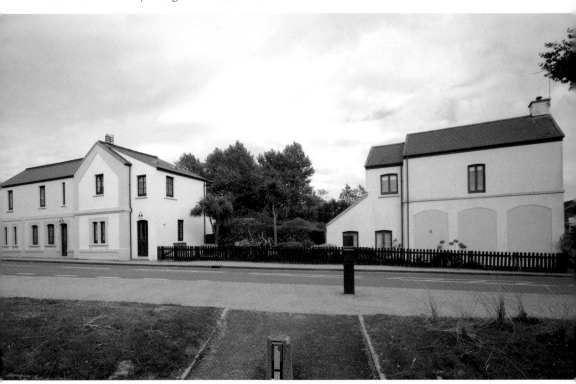

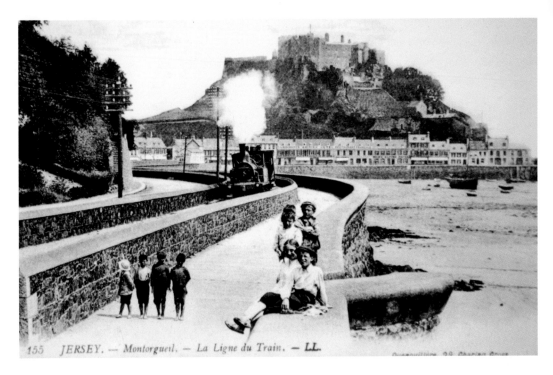

155 JERSEY. — Montorgueil. — La Ligne du Train. — LL.

En Route to Gorey, After 1891 and 2011
As the line approached the terminus at Gorey Pier, it followed a winding course wedged between the seawall on one side and the coast road on the other. It is still a tight bend today, with the track of the old Jersey Eastern Railway line now covered by ornamental gardens.

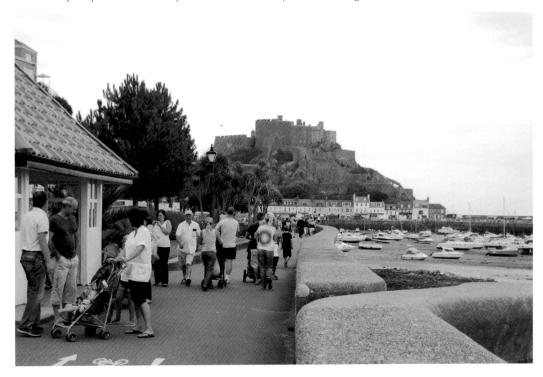

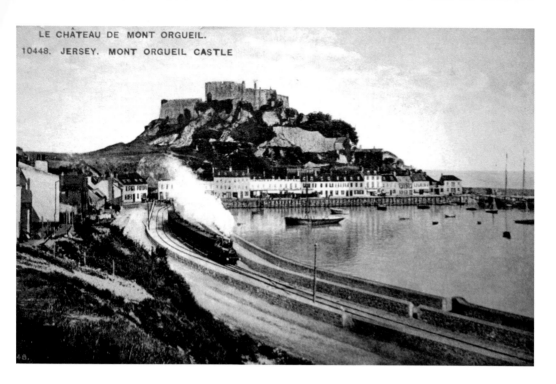

LE CHÂTEAU DE MONT ORGUEIL.
10448. JERSEY. MONT ORGUEIL CASTLE

Gorey Pier (Late Mont Orgueil) Terminus of The Jersey Eastern Railway

Gorey Pier Station, under the shadow of Mont Orgueil Castle, was opened on Monday, 25 May 1891 to coincide with Queen Victoria's birthday. The line was extended to facilitate the transportation of passengers arriving on the steamer from Carteret in Normandy. This much photographed panoramic view of the castle and harbour at Gorey taken in the early 1900s, shows the Jersey Eastern Railway Gorey Pier Terminus wedged between the houses and the sea wall. The station buildings have long gone and it is difficult to capture exactly the same view in 2011 due to urban development and tree growth.

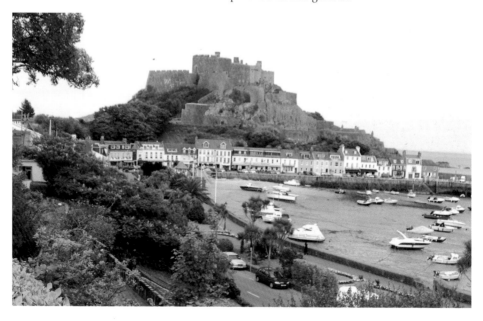

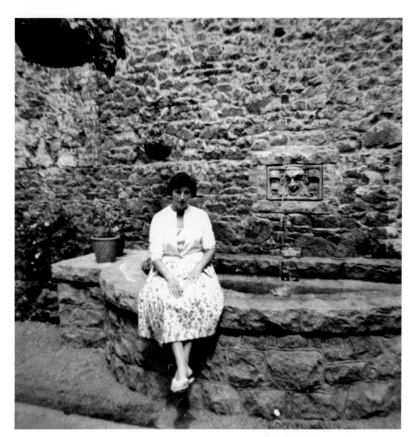

The Wishing Well, Gorey, 1961 and 2011
A demure Jacqueline Bate sitting on The Wishing Well at Gorey in June 1961 and the same well in 2011.

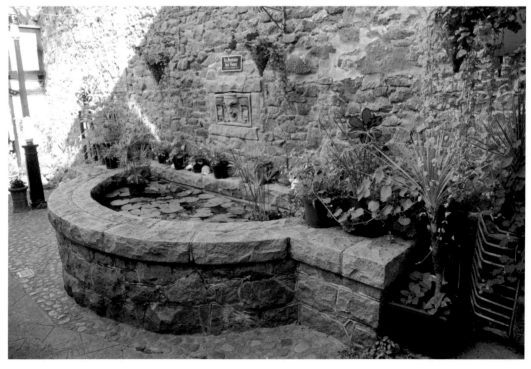

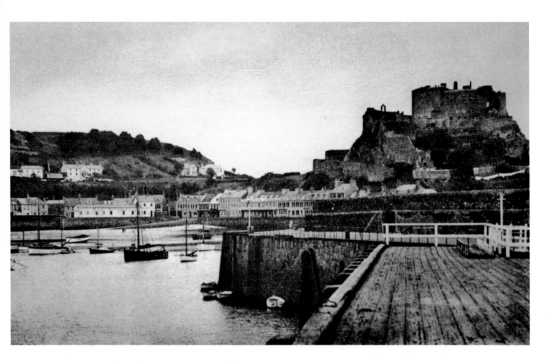

Mont Orgueil Castle From The Breakwater

One last look at Mont Orgueil Castle from the end of the Pier. The older photograph was taken pre 1929 before the Jersey Eastern Railway closed as Gorey Station is still standing at the far side of the harbour. Quite a contrast from the view captured in 2004 where the harbour is chock-full of little boats and the café, shipping and customs offices have been built on the end of the breakwater.

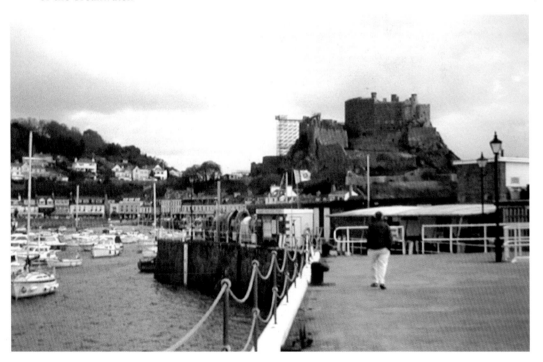

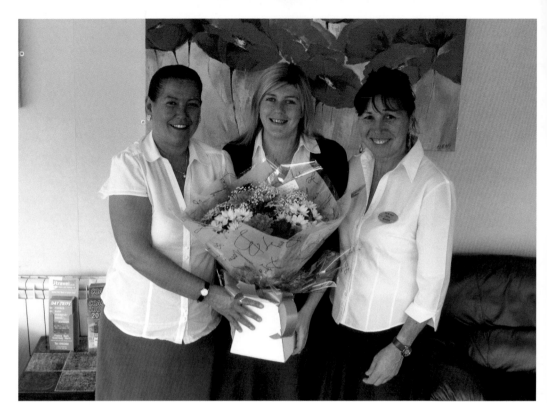

Until We Meet Again!
Three little maids from a ladies' seminary at the Old Court House Hotel, Gorey Village (with due reverence to Gilbert & Sullivan's *The Mikado*).

Acknowledgements

Compilation of this book would not have been possible without all the help and support that I have received from the following organisations and individuals for which I offer my sincere and grateful thanks:-

Richard Blampied and staff of Aurum Manufacturing Jewellers; Richard Smale, Paul Winch and staff of the Old Court House Hotel, Gorey; Margriet Barnes and staff of the St Brelade's Bay Hotel, St Brelade's Bay; Anna Baghiani of the Société Jersiaise; Liz Vivian, Lyndon and Sam Pallot of the Pallot Steam, Motor & General Museum; Chief Fire Officer Mark James and Crew Manager Jason Betts of Jersey Fire & Rescue Service; Jackie Gully of Jersey Tourism; photographers Alexis Militis and Matt Porteous; collections of the late Denis Holmes and the late George A. Rogers; individuals Michelle Cudlipp, Gaynor and Gerald Davis, Maria Gouveia, Karen Hardie, Cheryl Holmes-De La Haye, Georgie Mabbs, Jamie Lee O'Neill, Valerie Pinel and last, but not least, Lauren Richards, Apprentice Photographer.

Please accept my apologies if I have inadvertently missed anyone out from the above list.

Keith E. Morgan